SMALL TIME LIFE
ANDRÉ STITT

Edited by Locus+ and Duncan McCorquodale

Cover photograph by Pietro Pellini

Produced by Duncan McCorquodale
Designed by Joe Ewart & Niall Sweeney for Society

Printed in the European Union

ISBN 1 901033 67 8

British Library cataloguing-in-publication data. A catalogue record of this book is available from The British Library.

Roddy Hunter is a performance artist, writer and curator who is currently Associate Director of Visual Performance and a funded researcher at Dartington College of Arts.

Dr Al Ackerman is a Vietnam veteran and counter cultural commentator based in Baltimore. He has had several anthologies published including *The Blaster Al Ackerman Omnibus*, Feh! Press, New York, 1995.

André Stitt would like to acknowledge the love and support of Alan Hunter (teacher and friend RIP), Rev Gilbert Toff (between Portland and Sacremento 1990), Snow Girl (fi'n dy garu di), countless friends, artists and extended family.

Photography:
Peter McKinny, Tara Babel, Trevor Wray, Tony Clark, High Performance, Patty Ackerman, Roger Smith, Mark Thompson, Steven Durland, Jill Burnham, Shaun Caton, Daniel Plunkett, Lukasz Guzak, Alex Pazmandy, Krystof Miller, François Bergeran, Kerren Kelly, James Cobb, Pietro Pellini, Matt Hawthorn, Mamiko Kawabata, Andrew Whitaker, David Aebi, Gary Winters, Pierre Labourde, Mark Tillie, Simon Herbert, Galerie Jesperson, Denmark, X-Teresa, Mexica City, Bootsy Holler, Michael Northam and Jon Benley.

Locus+
17, 3rd Floor Wards Building
31-39 High Bridge
Newcastle upon Tyne
NE1 1EW, UK
t: +44 (0) 191 233 1450
f: +44 (0) 191 233 1451
e: locus+@newart.demon.co.uk
u: www.locusplus.org.uk

Black Dog Publishing Limited
5 Ravenscroft Street
London E2 7SH, UK
t: +44 (0)20 7613 1922
f: +44 (0)20 7613 1944
e: info@bdp.demon.co.uk

Black Dog Publishing
Architecture Art Design Fashion History Photography Theory and Things

SMALL TIME LIFE

ANDRÉ STITT

SCHOOL OF THE MUSEUM
OF FINE ARTS – BOSTON

TO ADVANCE YOUR EXPERIENCE UPON
THE WORLD OF PHENOMENA IS DELUSION.
WHEN THE WORLD OF PHENOMENA
COMES FORTH AND EXPERIENCES
ITSELF IT IS ENLIGHTENMENT.

DOGEN

WE'RE THE MIDDLE CHILDREN
OF HISTORY, MAN. NO PURPOSE, OR PLACE.
WE HAVE NO GREAT WAR.
NO GREAT DEPRESSION.
OUR GREAT WAR IS THE SPIRITUAL WAR.
OUR GREAT DEPRESSION IS OUR LIVES.

TYLER DURDEN

STATEMENT

'Akshuns' are located in a formative experience and a response to an encoded past embodied in the present that identifies with the marginalised and dispossessed. Social and ethnic cleansing becomes global cleansing via inquisition technology. The human body and, by association, all life, becomes the unknowing and disempowered object of surveillance.

The akshuns seek to embody and identify with processes of transition, the resolution of conflict, community and communion. These elements constitute an evocation of the individual and communal body on a journey towards redemption.

A treatment towards a new communionism.

Every akshun is a performance of consciousness.

INTRODUCTION
RODDY HUNTER

And if there is still one hellish, truly accursed thing in our time, it is our artistic dallying with forms, instead of being like victims burnt at the stake, signaling through the flames.

Antonin Artaud [1]

What matters most is how well you walk through the fire.

Charles Bukowski [2]

A rapidly growing acquaintance with performance artist André Stitt's work has developed within the milieu of contemporary art over recent years. Interestingly though, this recognition notwithstanding, Stitt's practice has evolved analogically for some time with concerns of contexts and communities that seem to sometimes occupy all too distant parallels with the art world, with the consequences for art of Stitt's approximation of the customary breach between innovative artwork and the practice of community ideals. (Seldom written of or realised elsewhere.) Stitt, himself, perceives the locus of this approximation to be his audience themselves, whether they are accustomed to contemporary art practices or not. The intensity of his actions within a performance stress – if not insist upon – reasons for a revision of personal and collective roles, with Stitt's principal often being to expose himself and his audience fully to his own, genuine heart of darkness: his approach to it, experience of it and recovery from it.

The extent to which Stitt regularly exposes himself to traumatic psychic disturbances might suggest that he has been somewhat emotionally immunised against this pain by the necessity of previous forays. Stitt is able to recall and embody states of pain in performance from which to begin a journey of redemption in the presence of his audience. The development of Stitt's oeuvre has involved a metaphorical process of sentient immunology that has increased the artist's reaction to psychic toxins and has allowed him to resist or, if need be, overcome full-blown psychic disturbance. In addition, Stitt's work references the arena of critical consideration; the tenets and idioms of his art have repercussions for understanding the praxis of art and life.

André Stitt's vow to his art practice – to attest to his and other's human weaknesses – commits him to avoiding what he perceives as the false consciousness of addiction to false consciousness; Stitt regards addiction as a behavioural state that imagines false or apparent motives, and that this dysfunction operates cyclically – resulting in a diminished ability to recognise, ultimately, what one's true interests are. In this context, Stitt cannot maintain his work's pivotal discourse of acknowledging weakness. The innumerable double binds suggested by this state of being also prompt a life whereby the immediacy of the artist's performances, or 'akshuns',

necessarily impinge upon both his psyche and his relationship with the world – its objects, subjects and histories. Stitt re-presents these double binds to his audience as punishing and inescapable dilemmas wherein one can no longer ignore any bad faith left in oneself at the end of an 'akshun'. The performances capture an acute synthesis of fear and terror, directed in the pursuit of a life of love reconcilable and answerable to itself.

It was written of Antonin Artaud that he "expected from theatre far more than it could ever give: salvation" and Stitt demonstrates a similar relationship with visual art, reconciling his Self with a re-forging of the forms and archetypes of his work.[3] Such individuation of artistic form obliges alterations to the matrix and functions of the artist's work, possibly allowing it to find integration within new contexts of culture or community. Other artists, such as Beuys, Muhl, Trocchi, and even Warhol have been concerned with this aspiration in their own distinctive ways.[4] All envisage a new locale for art existing beyond the conceptual and actual specifications of the places and means normally reserved for its execution. Stitt, however, travels to the heart of pre-existing communities that he feels are typified by dysfunction and addiction – the twin poles of false consciousness – to make that place, generically and specifically, the site of his work.

As Stitt regards false consciousness as invariably pervasive, most of these sites have themselves been generic. His early work in Belfast was personified by street works which typified (and sometimes closely parodied) the state of 'normality' arising from living within the context of the "Troubles". Performance as a series of guerrilla actions, inhabiting

prevailing forms of social neurosis rather than commonly recognisable signifiers of artwork. Performances involving bomb scares, telephone boxes, sandwich boards, Belfast newspaper headlines and photographs, camouflage clothing. These tactics were replicated on Stitt's later arrival in London in 1980 and extended to semi-secluded 'akshuns' (sometimes devised for camera) by railway lines and in forests. Stitt has since made street works in many different countries, and has, to differing extents, psychically 'projected' the specifically generic urban map of Belfast onto foreign cities or contexts to replicate similar tactics in devising his akshuns. In one work, *Burnt Ta Fuck* (1997) in Tampere, Finland, Stitt lowered an officially erected Union Jack flag to half-mast before making his way on foot and at a pace across town to a second site, dragging a table behind him. On arrival he covered the table with blood, cut a rectangle from the previously white tablecloth and erected it as a blood-red flag. Nearby were also a childhood photograph of the artist and a looped audio recording of RUC officers approaching the scene of a newly discovered dead body.

The imagery and functions of these works and others partly demonstrate Stitt's fascinations with the archetypal figure of the 'Trickster' – revered by the North American Winnebago Indians – and the psycho-pathological experimentation of European aktionists, such as Nitsch and Schwarzkogler. These discoveries, made early on in his work, have had a concurrent and irreversible affect on his development. The gratification of one's primary needs as an initial negotiation of one's identity served to link these discoveries

in the mind of the young artist to immoderate, if not sometimes humorous, aesthetic and ethical effect. Stitt interbreeds these cultural and essentially performative, forms and generates, metis-like, both an artistic sensibility of heroic infantilism and the embodiment of Stitt himself as a quasi-societal scapegoat. A recurrence of motifs – such as his literal action of tarring and feathering himself in later works – demonstrates the compulsion of this internal logic.

The influence of Stitt's upbringing in 1960s-70s Belfast also, however, clearly has a lot to do with the emergence of this type of imagery. The roots of Stitt's imagery and material are usually traceable either to his seemingly eternal Trickster cycle, or to visual reconstructions of Belfast childhood memories, if not in some measure to both. While the arresting sight of Stitt excessively saturating his body with ketchup, oil, mayonnaise and other foodstuffs derive from the Trickster, other actions, such as the tarring and feathering of the body, are clear reconstructions of past communal traumas. Whereas the Trickster aims to satisfy primary needs, Stitt as an adult seems to recreate, or remind himself of, harrowing cruelties seen or heard about on Belfast streets in order to resuscitate a concussed memory. Although the Trickster has a beneficial social role in reflecting universal disorder, Stitt's self-enforced engagement with motifs of childhood and cultural trauma makes for an unusually complex state of being – another fugue state, to an extent – in performance. It also binds each akshun with Stitt's main theme over all his work. The destruction of his own earliest community, through the prevalence of sectarianism in his case, tangibly links his

experience with those who have or are experiencing similar dysfunction elsewhere.

The success of Stitt's work depends upon the artist's ability to immerse himself in a matrix of personal and cultural traumas, whilst simultaneously retaining a necessary degree of immunity. A difficulty conceivably arises if one contrived an addiction to the antigens of this matrix so as to embody increasingly a scapegoat who would offer to match any degree of false consciousness from all comers. This, in conjunction with a conspiring overcompensation of alcohol and drugs, happened to Stitt and resulted in a severe physical and mental breakdown in 1992. He says of this time: "There was a strange sense of logic to becoming a failure; one could actually be quite self-righteous about it."[5] Therein lies the risk: the risk that too much will not be enough and the effects of immunisation become addictive. The consequences were possibly wholly unworthy of the risk. Stitt found himself largely unable to generate any artwork meaningful to himself and realised his only option would be to return to the matrix of his breakdown to devise solutions for evolving some kind of artistic and personal redemption. At this time, Stitt, in many ways, re-appraised or re-valued the peculiarly shamanic, and nomadic, aspect of the Trickster and thus re-established a role for himself as an artist whose work could again relate to community. It must have also re-occurred to him at this time that his native Irish culture was itinerantly migrant and thus the Trickster was re-galvanised and reconciled itself with a new sense of urgency and universality.

This understanding and use of such symbolism is clearly not arbitrary to Stitt's

development as an artist, nor is it simply convenient. Stitt developed a practice in performance to escape certain frustrations imposed by representational and formal economies of painting. When he burnt his paintings in front of the art school in Belfast in 1978, and simultaneously shifted his paradigm material from paint to blood, the metaphor employed was as much preoccupied with a concept of re-birth as it was with a formal desire for 'authenticity'. It may seem ironic that despite the pioneering techniques and ideas pursued by modern painters and brought to bear upon these questions of representation and function, Stitt has always felt inherently satisfied with his use of metaphoric and symbolic devices. It is clear that in his akshuns Stitt regards symbology in art less as an obstacle to be deciphered and more as an instinct related to an uncivilised, unreconstructed, uncorrupted source such as the Jungian unconscious. Symbology is, in fact, vital to the generation and understanding of Stitt's art as he considers it to predate himself and his work and also to hold universal significance, allowing him an integrity of work in different contexts and conditions. Of pouring cheap foodstuffs over his body, he says: "By metaphorical extension the body becomes trash, devalued by the culture, a site wounded and traumatised – not maybe in everyday life in a physical sense, but certainly in a mental and psychological sense."[6]

Stitt is keen to encourage the bearing of witness to such a wounding and traumatising of the psychic body – and audience members often reciprocate. I have personally seen, on more than one occasion and in more than one context, extraordinary, practically uncanny, spontaneous and eruptive outbursts of emotion in unplanned dialogues between Stitt and members of his audience. These are not disingenuous acts of false consciousness; the akshuns do not invariably render overt physical displays in audience members, nor are they intended to. This work is not evangelical: it relies on dialogue rather than preaching, spirituality rather than dogma. Shared consciousness itself occupies the fulcrum of the aesthetic experience. This is what lends Stitt's akshuns their uniqueness; artist and audience embody – albeit temporarily – a community. The methodological framework of this contemporary artist thus shapes conditions for genuine encounter and meaningful dialogue.

NOTES

1 Artaud, Antonin, *The Theatre and its Double*, New York: Grove Press, 1958.

2 Bukowski, Charles, "how is your heart?", *You Get So Alone at Times That It Just Makes Sense*, Santa Rosa, CA: Black Sparrow Press, 1997.

3 Simon, A., quoted in *Artaud on Theatre*, Claude Schumacher ed., London: Methuen, 1991, p. xiii.

4 These different artists have all declared 'manifestos' in favour of this aspiration. Joseph Beuys famously championed The Free International University; Otto Muhl realised his manifesto for the AA Commune; Alexander Trocchi aimed to create an interconnection of Sigma centres and Andy Warhol successfully arranged the "personality utopia" that was The Factory.

5 André Stitt in conversation with the author in Cardiff, Summer 2000.

6 André Stitt in conversation with the author in Cardiff, Summer 2000.

WHY DID YOU STEAL MY WATCH?
AL ACKERMAN

Stan Stitt – or Stan the Geek – as he was known professionally, had been the most successful young geek of his generation. In his colourful costume of fur, feathers and filth, he entertained and decapitated chickens with his flashing teeth before all the crowned heads of Europe. He had guzzled the blood of rats and snakes to a tumultuous ovation at the White House, where he played second on the bill to ol' Blue eyes himself. Yet with all his success he was clearly a disturbed young man. Tormented, even, one might say. I saw that right away. For one thing, although the day was bright and clear, he showed up for his appointment wearing a pair of high-top galoshes, which he refused to shed even when he was seated and in the comfort of my water-proof office. T'was, as I was soon to learn, but a minor symptom masking a larger, more deeply rooted problem which was utterly alien to what we know of the earth and it's organic life. In a word his complaint was that he suffered from memories – horrible, nightmarish, childhood memories.

"Slobbering! Slobbering!" he giggled "Hideous and obscene! Drooling and oozing and running and pouring over the shoes. The shoes! Ah, God... Cooler tonight with some chance of afternoon showers. The temperature currently in the Mile High City area is 74.3°." (I realised with a start he was picking up Denver. But it didn't last long for almost immediately his voice skipped, a testimony to the weird flitty state he was now in) "It's

getting dark, Roy! Did you remember to roll the windows up on the car? When you didn't think I saw you but I did. The recorder creature. You hear a sound over there. It looks like an electric eye shining and winking at you. But you can't quite figure it out. Then you realise this is no electric eye. This lens of this device, whatever it is, has legs on it. And this creature signals behind you, to what looks like a boy in a bellhops uniform. There's a little flurry of movement. It starts recording you then."

In all of Stitt's work, an amazing shamanistic energy is felt. In all his akshuns – whether it be contriving to get himself arrested on London's underground for acting like a 'geek', or repeatedly plunging his head into caustic solution so as to nearly blind himself, or setting his shorts and turban ablaze in the name of "my Masonic brothers everywhere", in all these akshuns we find him busy pushing that terrible mystic envelope that all men call 'ladrones'. He also liked to visit my home whenever possible, and would invariably consume a quart of sweet wine and then spend the rest of the evening down on the floor, rolling, rolling.... As one onlooker described it. "First he'd roll this way, then he'd roll that way." Yes, and this frenzy of rolling and thrashing never failed to give every indication that he was engaged in a titanic struggle with unseen forces, and had something that sounded like a wet buzzer in his seat.... And now they tell me he's written a book about these things, his experiences. The mind staggers.

ART IS NOT A MIRROR

Art is Not a Mirror, It's A Fucking Hammer, City Centre, Belfast, 1978

In 1976 I came straight out of school and went on to a Foundation at Ulster Polytechnic. I was principally working in painting, but I was also aware that I wanted to speak in a wider context, something non-hermetic to an Art School. I had grown up through the troubles in Belfast and this was something that informed my practice as an artist. This led me on to the premise of art not being a mirror – but actually being a hammer, something less benign that smashes through. I started to work on a series called *Art Is Not A Mirror It's A Fucking Hammer* which became a functioning title over the next few years. To begin with, this work took the form of simple graffiti on walls around Belfast. They were executed quickly and intuitively, you know "like what will we do today?" For instance, it moved into writing "boring" everywhere, and dating the time on the wall. This wall is "boring" at such and such a time on this date. There was a humour about it. I also liked the idea that people just come upon it – "what the hell is that, who would want to write that on a wall and actually sign it and date it?"

The work moved between two contexts. The first would be private experimentation, ritualised actions. I became fixated on the nature of using art to recondition myself, specific to responses that I had growing up in the environment of Belfast. The second facet was the public face – what had been carried out in private could then be honed and submitted to public activity. It became broader, something to do with creating the

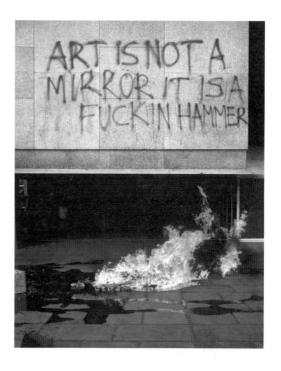

show, creating the spectacle, an intrusion into normal day-to-day reality.

In *Art Is Not A Mirror It's A Fucking Hammer* I burnt all my paintings in front of the Art School in 1978, a building situated in Belfast City Centre. There was a movement from the institution out into public space. During the burning of the paintings a bucket of blood mixed with rotten meat was poured over me as a reaction against the formality of an art school system and, indeed, the formality of creating art: paint to blood, synthetic to organic. From an early age I had an interest in ritualising actions within traditions – anything from Northern American cultures through to my own indigenous Celtic culture. My interest in Celtic culture was

problematic because I was becoming increasingly aware of my own Protestant heritage and tradition. I felt a real connection to other cultures that I identified as having been dispossessed, marginalised, in some instances eradicated. It was difficult growing up and living in Northern Ireland. I was British as well as Irish, living a sense of a colonial divide. Hence the identification with eradicated cultures, as I felt marginalised myself. Being an artist was an attempt to find a purpose or an identity, to assert my own individuality.

This was not only a question of locating but purposefully dislocating. I was putting myself in extreme situations that started to centre upon the body, specifically my own body. I felt somehow inadequate, having a sense of low self-esteem. I was trying to locate that within a history; not only my own personal history but a history of what I'd come from and how that identified with other groups globally. The private and communal contexts were happening in parallel. Both aspects were typified by an understanding of ritual and creating work in mutualised contexts. The structure to the work was both ritualised and spontaneous.

At this point I was becoming more aware of performance through meeting my tutor and practising artist Alastair MacLennan. I was experimenting with my own feelings of inadequacy within that situation, using various permutations of a series of nine elements to create a structure to work within for the actions (from this point on what I would call "akshuns"). Each element – from dog shit, which I would smear over myself – through to copies of the Belfast Telegraph – would refer to the nine years of the Troubles.

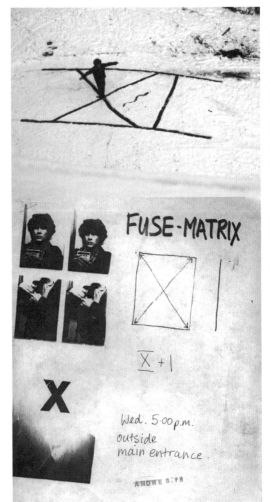

top: *Snow Matrix*, The Mansion, Dunmurry, N. Ireland, 1979; bottom: poster for *Fuse Matrix*, City Centre, Belfast, 1978

No one else in Belfast at the time was working in such a confrontational way. The works were also typified by a use of Roman numerals, which I would imprint as a gigantic matrix in public space, in pieces such as *Snowmatrix* and *Bodymatrix*. The grid of the matrix was an attempt to map out space, to define a system of sorts. Alastair was instrumental in making me see an alternative way of producing work. I remember asking him if he could teach me 'performance art' and he just laughed.

An early piece, *Sound and Vision*, employed a very simple Jackson Pollock type painting akshun, splattering industrial paint on heavy black plastic. It was made in collaboration with drummer Peter McKinney. I would create rhythms with the paint whilst he drummed away, both of us bouncing off one another. The piece took place in a deserted office block in Belfast, and an investigation of disused spaces in and around Belfast became important to me, to investigate the energy of community that was embedded in these environments. The akshuns extracted this energy and fed it into ritualised activity. Again it was about defining a system, recovering a sense of place, struggling for a sense of life within the imprint of oppression. People are conditioned by the performance of space, which in Belfast was mapped out as a particularly acute reflection of local conditions. What the Troubles had constructed, in terms of checkpoints, of 'no-go' areas, fed back into this conditioning, creating a cycle that continued to feed on itself – the destruction of the community. This is what I feel about most of my life; that it's been a spiritual journey to do with the spirit of place, the spirit of people. This has tended to be a journey into some dark aspects of myself that I confront and try to somehow expose – to face the fear of what those things meant within me, and within any culture that I was living in. So those forces wouldn't have power over me any more.

I took material from a bombed-out corner shop – burnt-out wood, old packaging, mundane objects – and incorporated them as elements in the *Matrix* series, laying them out in rows on the street as part of the grid. In terms of a social archaeology on one level the bombing of the shop could have been sectarian, but it was also ambiguous. The Troubles also gave people an excuse to "take care of business"; not all punishment beatings were politically motivated. An understanding of the symptoms of conflict does not necessarily lead to the cycle being broken. The immediate context was one of a continual breaking down and burning out of community. If someone made a show of caring, or becoming engaged, there could be possible repercussions. So people could act as a witness to these performance works without necessarily becoming engaged, could just walk on. Everyone in Belfast could theoretically relate to that, simply because everyone had that experience.

Negotiating an urban environment in Belfast on a daily basis was very difficult; you were subjected to searches – sometimes even strip-searches – on a regular basis. Life was not normal. You questioned everything in the environment. Everything became suspicious. In a series of body pieces over a few years I would lie in the streets, covered in a shroud, in a chalked out area, surrounded by the detritus, producing an alternative version of the 'official' matrix. People tended to ignore me. Was I a victim of a punishment beating? I could hear their voices, their footsteps as they walked past, but I couldn't see them. I had no dignity as a human being in this context. Sometimes the army would turn up and question me. On occasion Peter McKinny would act as a kind of interpreter with the officers. There was a tangible sense of aggression in these confrontations. I was taken away and interrogated at the police station. When I said I was an artist the invariable response was "piss-artist".

AKSHUN MAN! TRICKSTER!

I was making performances because they couldn't be possessed, playing games wherein the whole thing would become dysfunctional, investigating how to turn a structure inside out. By 1979 I started to identify with the humour within my work and the nature of the fool or, more aptly, the Trickster: an archetypal persona found in most cultures, the fool whose madness gives him licence to speak a wisdom that not all may want to hear. The Trickster has a core ethic of wanting to strategically re-structure the nature of reality. His function is to add disorder to order, and so make whole within the fixed bounds of what is permitted an experience of what is not permitted.

I started to develop this form of performance persona, something that was outside of myself yet intrinsically wrapped up in who I was. I started wearing paramilitary gear: camouflage fatigues and jacket, belt and ammo pouches, British army surplus that I had to get by mail order from London. It was a dangerous thing to do when walking about Belfast. Is this real, is this really happening, or is this a show? I was always being stopped and pinned down by patrols. The validation for the work was in the confrontation, throwing both their and my worst prejudices back at each other. There was fear at these times, but this was also an empowerment, a way of deconditioning oneself from the usual responses. I became the 'action man' reflecting the masculinity of the British Army and the outlawed paramilitaries – that hard military rationale that leaves no room for

intuitive action – but also subverting the situation by employing a destructive strain of humour. That masculine ethos was evident across different tribal groups: the army, the Royal Ulster Constabulary, the paramilitaries; the Ulster Defence Association would move me on, telling me to "wise up, or we'll kneecap you".

A number of students and friends occupied a large mansion house outside Belfast, living and creating work there. We had studios, bands were rehearsing, we lived communally and created networks with other friends who had left for England after their Foundation year. I was lead singer in a band called *Asked Mother*, which formed in 1977 and split up in 1979, gigging and recording at the same time as producing my own akshuns.

We held *Actions in the Mansion* over a period of a week. I made *In Transit* over five days, constantly moving through various rooms and corridors, stripping off in one room, going to another and getting dressed again, sleeping on a urine-drenched mattress, shitting and putting that shit on my body. The activity was monitored via a video relay, and people had the option to follow me with the camera. I was probably the only one within this loose association of people making explicit links to concepts of isolation and captivation as aligned to political activity within Northern Ireland. Internment had been introduced at the beginning of the 70s, and political prisoners held in Long Kesh. *In Transit* was made prior to the Hunger Strikes that saw ten Republican inmates die.

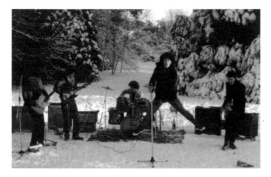

Ask Mother (band), The Mansion, Dunmurry, N. Ireland, 1978

I had begun to identify influences, as from 1977 onwards a network had erupted through the punk movement, and various related art activities. Groups who were working with various theoretical motivations, such as COUM Transmissions. I found references in magazines, in fanzines produced as photocopies, very cheap material, easily made and distributed. Many of the articles were concerned with looking at the edges of society, and what constituted artistic behaviour. I became aware of other action-based performance groups, especially the Viennese Aktionists and within that group particularly the work of Rudolph Schwarzkogler.

I took care to ensure that my work was documented. Originally I had just wanted the work to exist within that moment of doing – the reality and the experience of being there – but Alastair MacLennan suggested that perhaps I should document it so that I could actually view what I was doing. I needed a tool in order to understand the image, how it was being projected, because I was so much inside the performance I was unable to do that. Documentation became a means of understanding the images I was creating.

The images I was producing were sensitive to what was around me. The way that you move your body, the way you ergonomically use space and the way you float through it. Concepts loaded with metaphorical resonance. I have early memories of when we moved into a large housing estate when it was still being built. Initially there was a sense of optimism, but as the Troubles progressed things became negative. Human imposition changed the environment; it became part of the atmosphere. As a child I would play in the countryside and in the city. You shape-shifted through these places like the Trickster, shifting the reality. You touched a wall and felt on the other side the families who lived in the house, the energy that they exuded. When you grow up in street war and a dysfunctional community you're dealing with a tremendous energy. A sense of living in these areas, the atmosphere of human energy that you felt during the height of the Troubles… it was almost as if I couldn't breathe, that I was being suffocated.

I began a series in a derelict Protestant church building in Donegal Pass that I remembered from my childhood, around the corner from my granny's street. Members of my family had lived and worked in this locality, in the shipyard and in the gas works. By the end of the 70s any residual sense of community had been eradicated. I wanted a location that I could work in that had no constraints, that I could just move in and out of. I started working with elements that I found in the church, creating private rituals and explorations. I made an akshun with a derelict piano, an instrument with communal resonance; an echo of the songs that were sung, the hymns, the preaching and the sermons. I draped it in red, white and blue flags that I had found, relating to the

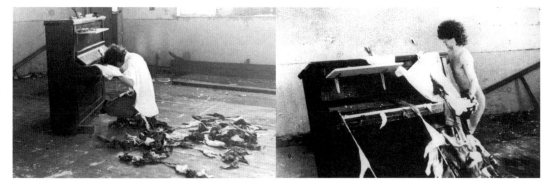

Piano Piece, The Church, Donegall Pass, Belfast, 1979

dominant Loyalist culture of the neighbourhood. I played the piano off-key, physically dismantling it piece by piece until it was destroyed. This was less a case of a politicised impulse than a case of working through cycles of destruction and re-building.

Akshuns were often made very early in the morning. At this point I was living with Tara Babel and we started making works. She would be the only member of the audience, in attendance for the whole period. I would make the akshun, she would take the photographs. It was as much about our relationship in getting to know each other. She came from a similar Protestant background but on the other side of town. We lived a couple of blocks away from the church. Nobody knew I was in there making work. Sometimes it was very frightening, sitting still in a dilapidated church surrounded by all the trouble outside.

I learnt a lot about arranging elements and objects within performance. I would made one work a week, some low key, others quite strenuous. This happened over a period of a year. Sometimes it would be a case of "let's go out and do this at this time and see what it's like in the light, or to see if the atmosphere changes in the building at this point". "What if we are disturbed?" which was a distinct possibility because we were always sneaking into the building. I was fascinated by the fact that we were sneaking in and out, and traces were left there. Who was going to find those traces? It's interesting now that the church has been totally rebuilt and I love that aspect; they don't know what took place there and now it's a new church.

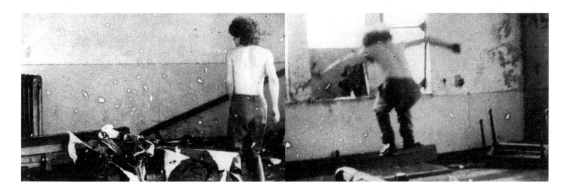

WHO IS BEING CONTROLLED HERE, JUST WHO IS BEING HYPNOTISED?

In counterpoint to the church pieces I was making other performances which were more obviously political in their content. Some were purposefully absurd in their symbolism. A performance called *Bomb Scare* started off with me wearing orange silk pyjamas, symbolising Protestant culture, with a large green phallus attached, symbolising Catholic culture. I posed in front of a hoarding advertising what at that time was a device called the 'confidential telephone'. You could call up this number and inform on whatever: suspicious goings-on, or someone in particular. I made a call informing the authorities that there was a bomb in the Co-operative Building in Belfast city centre, adjacent to the hoarding. I wasn't sure whether the call would be taken seriously; when the paramilitaries called in a bomb scare they would confirm their identity – and therefore serious intent – by using one of a number of predetermined codewords known to the authorities. However, the call was taken seriously, and within twenty minutes the crowds had been evacuated from the building and were milling around in the street. I walked through them and buried the dick in some nearby grassland; buried the phallus of Catholicism in the ground of Ulster. Sexual parochialism was endemic to both cultures, yet both communities were also "fucking each other over". Everybody was too preoccupied

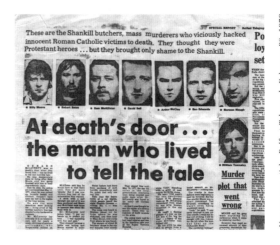

Newspaper article, *Belfast Telegraph*, February 20, 1979

with the bomb scare, the army patrols too, to even notice this absurd figure, or Tara taking photographs of the akshun.

I made *Sandwich Board* in relation to *Bomb Scare*, walking through the streets of Belfast wearing a sandwich board plastered with photos relating to the activities of the Shankhill Butchers, a notorious Protestant gang active between 1972 and 1977 who targeted and abducted innocent Catholics in black cabs, took them away to a Loyalist safe house and, in their words, 'interrogated' them – basically butchered them – before leaving the bodies in alley-ways. This wave of indiscriminate violence was horrific even in the context of Northern Ireland. They were members of an Ulster Volunteer Force paramilitary group, and their actions were abhorred even by their superiors.

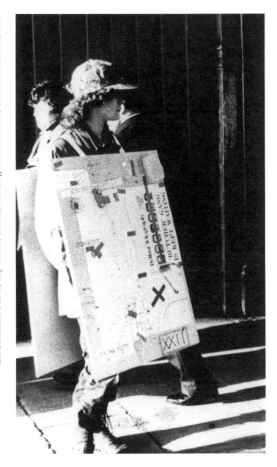

left: *Sandwich Board*, City Centre, Belfast, 1980; right: *Ghost Dance*, The Church, Belfst, 1980

At the time of *Sandwich Board* various members of the gang had gone through the judicial process and had been given a series of lengthy prison sentences. The sandwich board had headlines from the Belfast Newspaper, pictures of guns, knives, street maps and the location of the victims that were found. The media coverage magnified a pervasive sense of fear with continual reportage of stories, truths, lies, suspicions and intimidation. Even in my daily activity I was playing dangerous games, testing myself by walking down certain streets late at night, listening for cars, feeling the fear that they may slow down beside me. This would be in

the suburbs as well as in 'flashpoint' areas (where Protestant and Catholic communities bordered on each other). Whereas the former would once have been considered a safer place to walk through than the latter, the mythology of the Butchers had produced a chaotic fear zone. There was no longer the idea of a protected environment; the horror could happen in mundane locales.

I was preoccupied with this war zone, with a crazy environment that was considered 'normal'. Belfast could appear normal when you came away from the barricades, but what was the reality? The reality of the Shankhill Butchers? What were the reasons for targeting a specific person – their walk, their gender? What happened physically and psychically when they butchered people? The

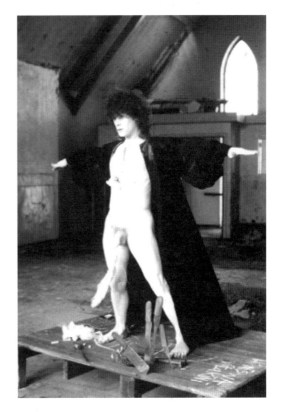

experience of using an interrogative power gone insane isn't different from any other war zone experience. People do unlikely things in desperate situations. There's also a perverse communal game being played out; why did the Shankhill Butchers gather together in the first place? What sort of individuals were involved? What was the belief structure that led them to believe that they were justified? The piece was enacted in a neutral area. It would have been foolhardy to do it in a divided area.

I also used versions of the Shankhill Butcher's knives as a foreground element of a work made for camera back at the church. *Ghost Dance* was constructed as perhaps more compositional than the earlier works, characterised by a ritual static akshun over an extended period of time during one day, trying to fly. A major part of these early explorations in akshun was a belief in that concept, a faith that it was okay to rise above your present circumstances and find some new territory to negotiate or dwell in. I was on a platform, on the front of which was written "Hi-Niswa-Vita-Kini" which means "we shall live again", a phrase derived from the infamous ghost dance ceremonies of the indigenous peoples of North America in the knowledge of their imminent genocide. Written in chalk on the reverse of a priest's cassock I was wearing was "Chocky Ar La", Gaelic for "our time will come", a saying used by Irish Republicans. By counterpointing primal aspirational beliefs from two such disparate cultures I was investigating the ways in which a shared experience of being colonised could somehow overcome that colonial superimposition; the ability to preserve an indigenous identity.

MUTANT SIGNALS AND PHYSICAL RESTRICTIONS

The first collaboration between myself and Tara, made in 1980, was done purely as a photographic akshun. There was a physical restriction to taking the photographs, because we had to operate the camera ourselves. It was a natural extension from the earlier pieces, informed by the need to create an interesting or disturbing image. It was as much a dialogue about who we were to each other as anything else.

There may not be much difference between making such images and taking pornographic photographs of each other, or making a video of us having sex. People do all sorts of weird and wonderful things in private; even producing an artefact and then going so far as to have it reproduced in specialist magazines, distributing them through a network. That was quite influential on our thinking at the time. What was private, what was real? What was narcissistic in this activity? Why would you want to carry that further? Like any art activity, it was taking something mundane and making it special; something that you could perhaps meditate on. I think the trick to making this

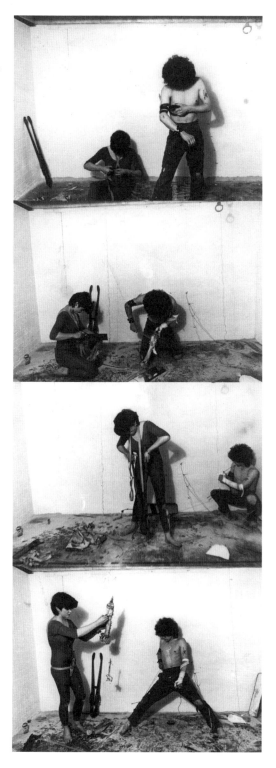

type of work was to avoid coming to a rational conclusion in advance. You couldn't necessarily predicate an akshun with the knowledge of a sure outcome. If you could have done there would be no reason for doing it.

Living in Belfast necessitated contemplating the idea of being constantly under surveillance, of having no privacy. Suddenly you found that you were the centre of the world stage, you were in the media and your street was on the news. So it was a case of "OK, we have a male and a female, making an akshun in the middle of Belfast and they are under surveillance". It was an attempt to win something back. A power struggle was going on. You were being looked at all the time but at the same time you felt you were second-class citizens: not quite Irish, not quite British. You didn't know what the hell you were supposed to be.

In terms of this psychic territory, a sense of optimism remained with me even in my darkest times. Drugs went hand in hand with that. The primary drug was alcohol – "getting off your face", "getting out of it". We used to really get out of it because it was a bad situation, and you were depressed and you were fed up with the situation. I was fascinated by using drugs for expansion. I had a lot of experiences with acid, and even more so with mescaline which, in particular, fed back into the nature of creating ritual. I was consuming literature and poetry about this, involved in correspondence with the mail art network with a lot of artists around the world. Everything was an expansion. Drugs were another component of that. We created experiments. When we were all living at the mansion we would experiment with acid, influenced by Ken Kesey – acid tests. We got

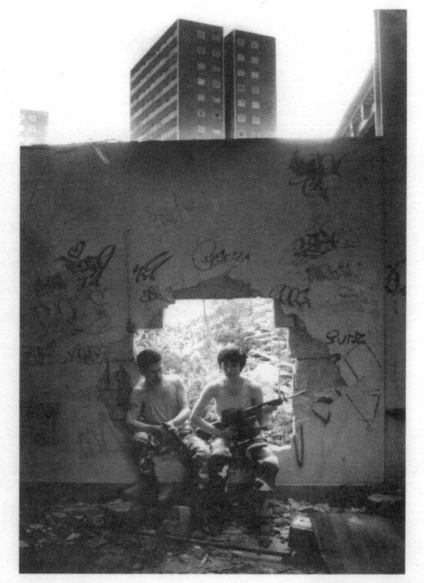

TILToTT

ANDRÉ STITT **TARA BABEL**

A DOCUMENT OF TEN YEARS OF PERFORMANCE WORK
1980 - 1990

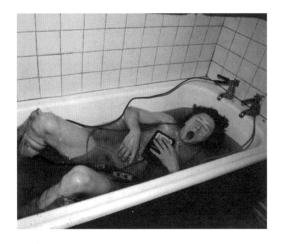

Abattoir, Derlett Street, Belfast, 1980

into amphetamines and different forms of speed and that became a whole way of operating for days and days on end – drawing in one room for a couple of days, sharing in the activity, people playing music. I was also clear about the practice of actually producing the akshuns. There was a discipline, so I didn't use drugs at that point during akshuns but they certainly informed some of the thinking behind the akshuns. Drugs were in a sense more recreational then. Later they became really dominant within the work but at this point they didn't seem to be detrimental. However, I was already having difficulties. I was quite prolific in producing a lot of work, but it was being informed by personal circumstances and alcohol in particular had a lot to do with that.

I was corresponding with a number of underground artists in the United States and this led to the foundation of a network of artists that I relied on to fix up performance events over there. There was a sense of working outside the establishment and creating your own network. I sought out people that I identified with. I needed to move somewhere else outside the confines of Northern Ireland. At this point a lot of my friends were feeling the same thing, so there was a convergence on London as a base where we could meet and operate from. There were a lot of like-minded people who came through these situations in Belfast, and also people that we'd met in England who'd come through similar, perhaps deprived, situations living on housing estates, who also wanted to make something better. We felt we were a generation that could effect some change.

In June 1980 I made a series of works, *Abattoir*, to tie up some loose ends. They were realised over an extended period of time, enacting what looked like torture in an abandoned house: simple akshuns of going underwater, cutting my mouth, tying wires around my cock and legs. I was ducking under the water then coming up again. I couldn't breathe. I was spluttering, almost drowning within the bath tub. The water in the bath was polluted – there were cow's feet in the water, a reference to rural identity. The physical debilitation of the work related to being caught, being subjected to something. This is what I remember. Again, a case of what was real? A Trickster thing.

There is a general perception that all performance is located in some kind of negative quagmire of guilt and shame that somehow needs to be purged and exorcised. Whilst this is an aspect of performance, it is not the only one: you should not forget that the reason you're doing this is to come out into the light. I've never perceived any performance that I've done as wholly negative. Perhaps a positive outcome may not be perceptible at that moment, but as time passes one catches glimpses. *Abattoir* produced images symbolic of the death throes

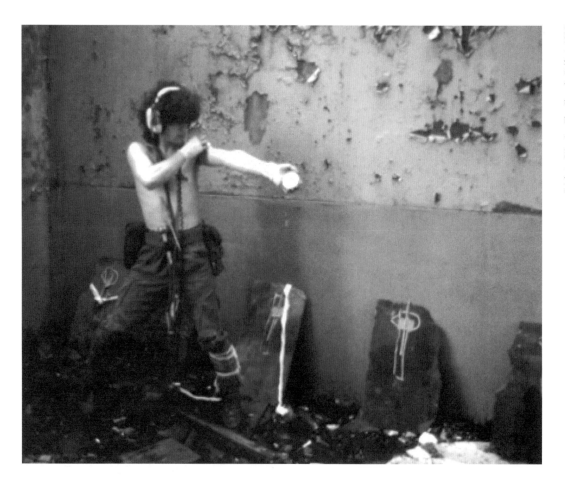

of culture, and the internal struggles and the external forces on that culture. You know that you're dying but you have to die to be reborn. Art operates in a spiritual context. It is a way of growing, albeit in public, an absolution from hidden fears and the feeling of being set apart. To find a way of belonging and participating. There is a lot to be said for the correct use of willpower, in wanting something good to happen.

There was a final akshun in the church in Belfast called *Trickster Warrior*. The building was in a state of collapse – the walls were peeling, the roof had caved in. I loved the idea of having worked over a period of a year in a space and then the building just falling in on itself, eating itself up. I liked that kind of aesthetic, a tragic metaphor. I kicked the shit out of slates. Defining akshuns, the destruction of the environment, the placing of my personal marks. I used axes as tools, something to both build and destroy with. I used headphones and a microphone that didn't work, so there was no way of addressing anyone: trying to create a dialogue yet systematically furthering the destruction.

The last akshun in Belfast was made at the artists' collective Art Research Exchange. *Exiles, Nomads and Vigilantes* was a series of tightly structured ritual akshuns for an

Let the People Rot, Islington Town Hall, London, 1980

audience in a small space. I anointed my body with oils, tied myself up with wires, I was attempting to go to a primary source, building the foundations of a hybrid language. I made a swastika out of wood from a local forest, and this formed the centrepiece of the akshun, a mythological structure denoting the four points of the world that I moved around. Of course the co-option of the swastika by the Nazis implied a fascist repression of tribal ideologies. An image of me in the bathtub from the *Abattoir* akshun was projected in the background, linking the immediate locality to broader environments and histories. The performance lasted about

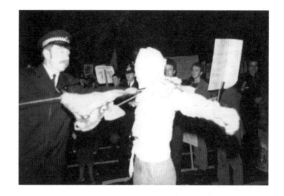

forty minutes. At each point of the compass I combusted magnesium, filling the space with smoke – fire being an important alchemical cleansing element; something that both destroys and purifies.

AIM SEEKING TARGET

Consumers Guide (with Tara Babel), Cabaret Futura, London, 1981

After that we converged on London and Tara and I started squatting in Islington. In addition to developing more collaborative akshuns I was doing gigs in nightclubs with a band called BMUS (Beam Me Up Scotty). During the evening I would act as MC, or read texts. I was collaborating with a number of guys who had studios on the squatting scene. We had access to equipment to create backing tracks and music, and were able to promote our own events in different locations around London, starting to work in different art-style nightclubs such as Cabaret Futura in 1981.

Tara and I made *Duck Patrol* – "out for a day in London" – a humorous idea about a real army patrol. Of course, it was nothing like an army patrol; we were carrying toy guns, with plastic ducks on our heads, giving out random duck calls "quack, quack". The

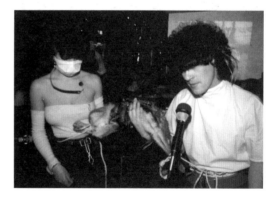

piece solicited a lot of attention as we moved down Oxford Street and through the West End. We acted as a catalyst, just letting things take their course. The akshun would have been much more dangerous to do in Belfast, so part of the concept was a reverse colonialism: bringing the Troubles back home, Tara and I stamping our identity in our new environment.

I was trying to find other venues to create work in, with other like-minded artists. It was important to operate within a wider communal context, to have a support network. These formative relationships with mainland Britain were built over a period of time. For instance, I worked at the Basement Group in Newcastle upon Tyne in the early 80s, an alternative space that presented the work of lots of different performers. *The Larynx*, was about being unable to articulate feelings – by this point Tara and I had had our first break-up and it was a traumatic time for me. Two images were projected on the back of the space: one of the inside of my mouth, the other of Tara holding her vagina open with a meat cleaver between her legs. The performance space was covered in a circle of earth and mud, I was wrapped up in the idea that I was a dog or a coyote. I had taken a lot of speed and ran on all fours around the circle, the akshun becoming more and more frenetic, until I would break out of the circle and repeatedly slam into the wall. Changing shape like the Trickster. Was I a man pretending to be a dog or a dog pretending to be a man?

This was a very violent performance and a portent of things to come. I used phosphorus which engulfed the space in toxic smoke. People were standing back or leaving, some seemingly worried about the fact that I might badly hurt myself. I wasn't aware – and didn't care – about the effect the work was having on the audience. If it was difficult for them then that was something I didn't feel I was responsible for. My work has always come from a deep personal response to the situation that I'm living with at any given time. I was confronting such situations in a

Duck Patrol (with Tara Babel), London, 1981

public context, and whilst that may seem to be egotistical it was necessary at that point for a number of years. There wasn't much dialogue or talking after the piece. Maybe they'd rather not talk about it. I never knew, and you could say this was also a portent of things to come. After most akshuns responses were almost never indicated, but I grew to value that; it was a way the akshun could filter through without having to generate immediate dialogue.

I became friends with the artist Roberta Graham, who was organising performance events at the Film-Makers' Co-operative. It was really my first chance to produce a structured performance in the context of my past and recent experiences of London; to talk about where I'd come from, why I was doing

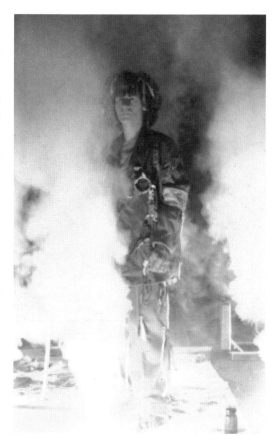

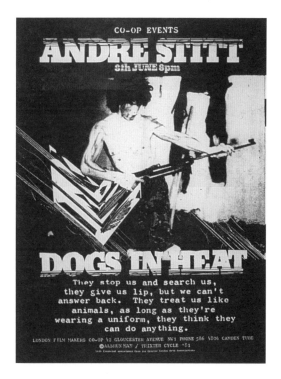

it, but to expand this within a wider political and artistic context – I could plan things in a London art context that were not possible in Belfast. There was less prejudice about the form. *Dogs In Heat* was a key performance within the *Akshun Man Trickster Cycle*. There were a lot of ritualised elements, very highly structured, and it was the first performance that I felt was successful structurally – in terms of aligning sound with akshun and negotiating a path through the akshuns. Projected visuals of Tara and I wrestling in a forest were juxtaposed with images of the Belfast 'Peace Line' – a wall that separated Catholic and Protestant communities. As in *The Larynx* I adopted the Trickster/Dog

persona, crawling around a white sheet covered in red, white and blue pigment, smeared with dog shit, accompanied by an audio track of barking hyenas. My legs were bound. I wore paramilitary and surgical clothes. I applied semen and oils onto my body. The akshun was, like all my works, 'in process'; it wasn't necessary to understand what was happening in advance, only to approach such a state in retrospect as part of an experimental process.

At this point I was moving into the *Hebrephrenic* part of the *Trickster* cycle. Hebrephrenia is characterised as a schizophrenic condition bound up with delusional behaviour, often quite silly but also very sinister. Whereas the Trickster was a primitive warrior type, an individual also preoccupied with his own self-image, the Hebrephrenic operated in a London

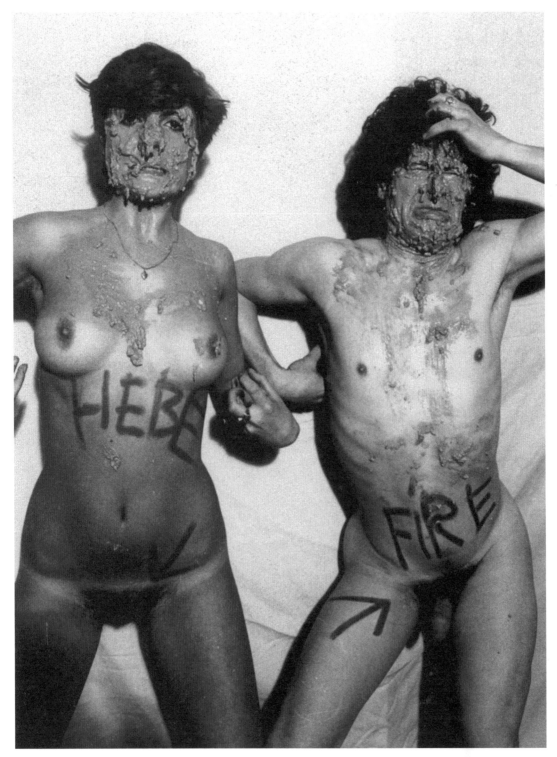

from *The Hebephrenic series (Hebe Fire in Head)* (with Tara Babell), Exiles Studio, London, 1981/1982

Tara Babel, Dr. Al Ackerman and André Stitt, San Antonio, Texas, June 1989

environment where there seemed to be more freedom to act weird. It was possible to meet more damaged people in the consumer environment of London than in Belfast.

Many of these akshuns came out of a script that Doctor Al Ackerman sent me. Al has been the longest of many correspondents, from 1979 to the present. He has lived what you could call an alternative lifestyle in the United States. He had been in the Vietnam war, and we have had a series of lively correspondences about those experiences and the nature of the way he was living. A trained doctor, he was practising at the time in Oregon. Every now and then he'd influence or become inspirational in a series of performances that I made, such as the *Hebrephrenic* series.

The *Hebrephrenic Akshuns* began to appear at various locations around London over a period of time: a little garage, Finsbury Park carnival, underground car parks. Although taking place ostensibly in the public domain, the works were again principally akshuns for the camera, in this case on the understanding that Tara as photographer had to follow me to each location. It was a case of: "You keep up with me, you do what you have to do, while I'm going on this trip". It was an adventure as well. I placed myself in these contexts, dressed silly, I'd be throwing myself around, which was quite bizarre. In squatting, of course, you're always in transition.

Increasingly, trashier aspects of culture – particulary consumer products and waste from American culture – were incorporated. The akshuns became more theatrical in terms of their structure – reliant on lighting and backing tracks, designed for a seated audience – yet simultaneously disruptive; the performance turned inside out. The viewer

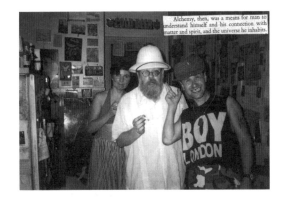

could see the mechanics of the performance. I remember that during this period Tara and I both became quite insane. We travelled to Northern Ireland with Roberta Graham and it got to the point where she couldn't handle us. Tara and I had our own language, our own way of communicating; it was unsocial, abnormal, and all part of the way that we were making the akshuns.

In *Six Degrees: Maximum Headroom*, at Waterloo Gallery in 1982, we had the band BMUS playing behind a sheet in the gallery, so you couldn't see them, just hear this tremendous industrial sound of grinding machinery. We hung forensic photographs in the space, in particular foregrounding an enlarged photograph of a Northern Ireland bomb victim on a stretcher. The original photograph was used by the police in an attempt to gather information by hypothetically shocking the public into giving information. questioned the validity of doing that, of disenfranchising the person from the body. We carried out a set of repetitive akshuns: laying the photo onto a stretcher, running with the stretcher across the space, setting it down, reversing direction, picking it up and running back to the original starting point. Again and again as the music from BMUS

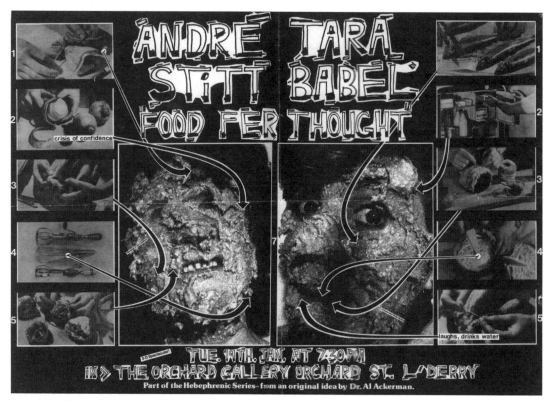

Food Fer Thought/The Hebephrenic (with Tara Babel), The Orchard Gallery, Londonderry, 1982

became more and more frenetic. This was done 'cold', a response to the use of the photograph and the negation of who the subject had been. This had been a real person, and the sacredness of this person was destroyed, by both the bomb and the forensic detail.

I also initiated a series of performances simply called the *Red* series. I have a strong sense of an inner imagination, an inner life, that also comes out of dreams and the interpretation of dreams. I was interested in ideas of alchemy, and psychology in alchemy. The *Red* series was sometimes called *Terra Inc* or *Terra Incognito No Man's Land* – it's that space between everything, the secretive space between realities. Coming through this *Hebrephrenic* series, the dream mythology and symbolism, was an attempt to further

negate my living presence and go into the viscera and mechanics of the body. The way the body was perceived, or used and abused, the disintegration of matter and trying to find out what's left.

The *Red* series was used in conjunction with other dance-like performances, images flashed up in rapid fire in a red space, with red lighting in nightclubs. Often the spaces were very tight, you were doing this on some bar-room floor or something, in some small club. BMUS would play whilst we did the akshun. We would open with videos and films. We hired a lot of Viennese Aktionist movies from the Film Co-operative as an introduction. The band would play a set, we would do our akshun, then depending on the nature of the show we'd have guests coming

left : *Terra Rituals*, Exiles Studio, London, 1982. right: photo of a bomb victim taken from police information, Le Mon Hotel Bombing, N. Ireland, 1978

and doing a solo spot, the band might finish off with another set, videos playing in the bar, that type of situation. It changed from show to show. The events were called *Zen Abattoir*. Tara and I learnt semaphore and we used this language within the performance. We were talking to each other but, again, not many people could understand. This was an extension of the private dialogue of our relationship.

During this period I was also making solo works, focused on minimal akshuns, combining all those elements that I was learning within the larger events and reducing them for smaller events. *Listen To Me* at the Sheffield Expanded Media Show in 1983 was a traumatic piece. I was yelling lines like, "I have the eyes of a professional killer, listen to me, you're not listening to me". The akshun concentrated on the abolition of personal relationships, the destruction of belief values, everything falling away from under one. This was during another breakdown between myself and Tara. Our relationship had been characterised by the high intensity of working and living together. I found it very difficult. I was living a very rarefied

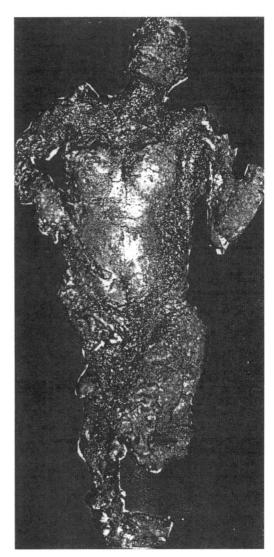

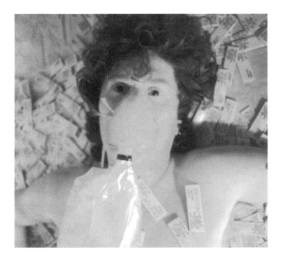

existence, separated from most people in terms of being on the dole, not being able to earn a living, all the time obsessed with creating performance work, working in the studio day in, day out, and then drinking and getting out of it and taking drugs. I was living in the context of many people within the squatting scene in London who were damaged to a certain extent; you were outsiders within society.

THE LIQUIDATION OF RESISTANCE

In 1983 I had my first invitation to the United States at Franklin Furnace as part of a weekend of Irish performance art. I brought together elements from the *Red* series, increasingly incorporating multi-media devices – video and slide and text projection, backing tapes, music and the spoken word – in an attempt to make the akshuns consumable for an American audience more familiar with that formal generic style of performance. I was in a poor psychological state. The Franklin Furnace akshun was very violent. I was smashing my head, smashing my body against the concrete floor, then going into the audience and pulling people off their seats, kicking people, very confrontational, violent akshuns. I felt extremely angry and took it out on the public. I eventually collapsed. At the time I felt very bad about it but it was over and done with, so what could I do? I had very little respect for myself and this was something that kept recurring in subsequent performances. I was stuck with my own conscience, often after the fact, and suffered terribly emotionally because of what had just happened. The other thing that started to happen was I realised that the performances gave me permission in that moment. I'm not saying that's right. I became a law unto myself and subsequently, of course, people wouldn't work with me. I had a bad name because of that, but that's what happened, that was the reality. I know now what was going on but at the time I didn't. I had no way

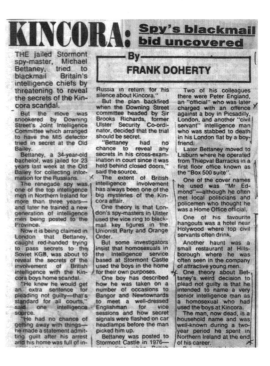

of gaining help to understand the position. I was increasing dependent on alcohol, and drugs. I felt an awful paranoia and fear of everything. I did not enjoy this time in New York at all.

I remember this phase quite clearly. In Geneva Tara and I made a work, following a formal piece in Fribourg, Switzerland, where we thought we would do the opposite: "ah fuck, let's just go and piss on an audience", so that's exactly what we did. I perceived the audience as being rather uptight, bourgeois people, a predominance of thirty-something married couples in this trendy squat, a sort of cafe. It was all very well-organised and it just

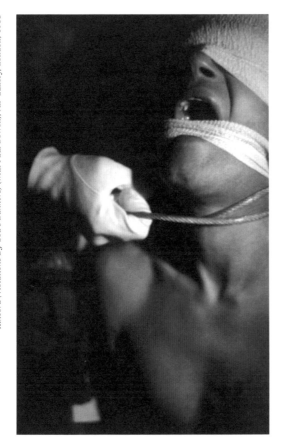

annoyed me. That was my response to the situation, unfortunately, at that point.

After the summer in Switzerland I returned to London and I met Paul Bowen, also a musician in a band in Belfast, and we began talking about recent investigations into Kincora Boys' Home in East Belfast and decided to make a series of performances about it. The boys living in Kincora Boys' Home were used by a sexual vice ring over a period of twenty years. Children were abused, used for prostitution, on occasion with visiting politicians and members of MI5 and MI6. One boy was murdered because he was going to talk. His decapitated body was found in the Lagan River in Belfast. It was a horrible

situation with a subsequent massive cover-up. Top ranking civil servants, policemen, intelligence and politicans were involved. Various groups such as the Orange Order, and a Protestant paramilitary group were implicated. We started to investigate other British institutions such as the Masonic Lodge. Whilst the Masons weren't implicated the whole affair smacked of elements within British institutions of secrecy, a lack of transparency. We implicated their forms of ritual within the performance.

Kincora (Violations by God's Bankers) became a documentary in terms of its production. We investigated the case, compiling information and newspaper reports going back ten years, producing a series of photographic images based on our own loose interpretations, depicting a struggle between two males engaged in submission and domination. The two of us were dressed in jock-straps, vests and little aprons, fetish regalia associated with Masonic ritual. We stood at two podiums, alternately reading ritual texts of subjugation and submission taken from both the Orange Order and the Masonic Lodge, with reportage from news clippings that we had researched. A collision between private worlds and public discourse, the latter straining to catch up after the fact.

Sexual presentation and subordinate patterns served as a means of achieving several aims that could be summarised under headings of self-preservation and handling fear in threatening situations. This would have included warding off attacks, avoiding punishment, obtaining access to food and other benefits and privileges. These were all accommodations whereby a subordinate could adapt to living with a sado-masochistic

guardian. Weakness could appease strength and avert danger by sexualising itself, offering in a symbolic way a sexual service to the strong.

The performance was a vehicle for the recognition that violence or pornography could be seductive. The masculinity and the imagery that came out of it was very compelling. It seemed unlikely that anyone could attempt to recreate these images without being compelled by them. Societal compulsion resulted in a need for exposure to extreme titillation or tabloid journalism.

A negation of sexuality, evident in earlier works, was also articulated in the imagery of this piece. There was a sequence within the performance where Paul and I fought each other. Both of us were trying to physically rape the other, smearing lard on each other's arses and wrestling. We had agreed prior to the akshun that we would simply go for it, give each other no quarter, within this section. Paul was larger and stronger than me, so it was a question of who was going to get the upper hand. Who was going to win and who was going to be submissive? It was a very theatrical set-up, yet suddenly at this point it became very real; a life and death struggle within fixed boundaries. Whilst this reflected the strong sexual connotations within the framework of the Kincora case, we were also trying to transmit a deep sense of compassion for what had happened to the victims.

CHANGE IS NOT A MOTEL

Subsequent performances with Tara were less predicated on a resolution of predetermined events – perhaps a reflection that I needed more room to move in terms of subject matter. The *Tourism* performances used a different kind of research, more subjective than in the Kincora work, which took the form of visiting exotic places. We questioned the nature of the tourist within the tourist environment, partly based on our own experiences as immigrants in a London culture. Like the *Hebrephrenic* series, and before that *Duck Patrol*, we went to locations and basically saw what happened. For instance I was making a series of akshuns round McDonald's outlets in London, drinking Thunderbird wine, my favourite tipple at the time. This asshole tourist.

The 80s were very egotistical, domineering, dog eat dog. I liked the idea of being a tourist in these times and implicating yourself in some of its worst aspects. Tara and I did this in parallel; we brought together private akshuns and worked out a structure. Both participants remained individual in their practice. It came together with a bang. At the Perfo Festival in Rotterdam in 1984 we created *Tourism* in a controlled space, constructing an 'imaginary tourism' typified by an over-abundance of trash culture relating to the United States. We hadn't been to, say, Texas but we presented our own mental projection of the stereotype. We incorporated a heavy disco beat, over which were female backing singers singing the words from tourist brochures, constructed by

a cut-up technique. "City Breaks. Passports and visas. Resorts. Sterling Price amendments. Alterations. Fly luggage. Car and hire. Bonding. UK security. Evening stroll. Balcony. Solarium" etc.. It was absurd, destructive entertainment. Drinking and vomiting and trying to eat as many burgers in a certain set period of time. I had a metal plate made with the word "Danger" on it, and during the performance I would constantly beat myself over the head with it. My head was bleeding, I was almost knocking myself out. I used elements that would regularly recur in the future: blue stripes painted on my body as a reference to Celtic woad, the dog symbol on cards and in neon templates.

Love Crimes was shown at the Project Centre in Dublin in 1984, and also had a sense of this propulsion. I had become interested in something that's private, the rituals that people carry out behind closed doors, locked into a hotel room. My ritual was about drinking, my relationships with women, the fantasy of a night on the town. In reality you were not going anywhere, you were stuck in a motel. It was a fantasy, but the fantasy became reality so you enacted the ritual. As a

backdrop there were various devices: videos, projected films of cityscapes at night, beautiful music made by Paul Bowen. It evoked the milieu of detective novels, seeing oneself as the heroic drinker, the artist, the detective in culture. My idea was to create a ritual out of the rituals of a contemporary context, cleaning the penis and balls again and again. Vomiting and drinking. In the end it's rather shabby, so everything becomes dysfunctional.

In terms of preparation for such works there was a matrix in which I found I could embed a positive energy, so things didn't go too haywire. That became a focal point for, in effect, holding me in position. I meditated before the performance, getting away from the actuality, to have that moment of "what exactly am I doing here, what's my motivation for doing this"? Performances were always structured within a frame, a structure in terms of sound, cueing, spoken text relating to the akshuns. There was enough freedom within each structure; five minutes of this sound, this changes into this dialogue, there's an akshun with this dialogue that lasts fifteen minutes. A sense of scoring or structure in the performance, a definite line of intention.

"LOOK SIR, IT'S PEANUT BUTTER!"

Love Crimes was comparable to the *Tourism* series, in that both were carnivalesque, a side-show, or a freak show. This in turn fed into *The Geek* series, again partly realised as a result of ongoing correspondence with Al Ackerman, who was writing about his experiences with geek shows and carnivals in the United States. I was fascinated by the idea

of the Geek being the person in the carnival who has somehow fallen from grace. They were usually an alcoholic, funnily enough. When the carnival hit town it was this sort of freak show, side-show attraction that was set apart, and the person would get down there into this pit and bite the head off chickens and snakes and stuff and generally be as mad

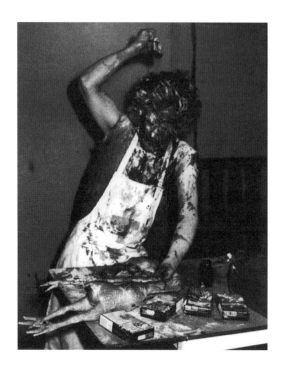

Paradise Passage, When the Shit Hits the Fan, Whitechapel, London, 1985

as hell. Then the sheriff would come along and close it down immediately. That's always where the kids went first, that was the main attraction. "See The Geek!"

I completely identified with the romance of the Geek. It gave me power over the situation – an illusionary power of course – but it satisfied me for quite a while. I made performances as the Geek on the London Underground where I would stop and talk to people, initiating quite spontaneous and intuitive confrontations. How do you deal with people when you're got up like this, with the ketchup and peanut butter on your face and all that kind of thing? They were manic akshuns within a normal environment. I was shouting, being incredibly abusive and would then suddenly switch to being very nice. I was delivering pieces of nonsensical information to them. I loved the idea of printed tracts, when you're given stuff in the street.

Something that looks like a religious tract but this complete madman was giving you this and really insisting that you have it and it's really of the greatest importance to your life. There was a lot of frantic movement, getting on and off trains, going to different stations. I had assistants turning up at a designated tube station and coming to take me away on a stretcher as I was still howling. They were dressed in white coats, taking me back to Bedlam.

In 1985 I did a Geek performance called *Financial Times*. I tried to give people fake money, insisting that they take it. I read the Financial Times; the Geek as Businessman. I also did Geek nightclub performances and akshuns, which referenced the traditional freak side-show. Carving up chickens, drinking and blowing fire. I became a side-show attraction at clubs and raves. I went into this willingly, I felt in control. In a perverse way I retained the power; I was the centre of attention, I could control the audience.

Some hip young Conservative party members had seen some photographs that I'd produced as a commission for *Tatler* magazine, which was titled *My Art Belongs to Dada* (which I rather liked). They thought it would be a wheeze to have a Geek performance for a young Tory party member's birthday party. When I was made the offer I was delighted to oblige. It was held at Wimbledon Civic Hall, a formal affair filled with tables and people eating food. I came in and did a pop birthday party event about a relationship between caricatures of Ronald Reagan and Margaret Thatcher, enacting various sexual perversions. That didn't go down too well. I had insisted on being paid before the gig. Somebody pulled the curtains

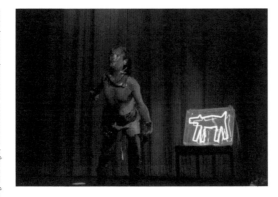

after fifteen minutes and that was that, but I carried on anyway, projecting these ridiculous voices. I was being deliberately direct, playing to the situation.

Tara and I were still working together. We were invited to the Belluard Festival in Switzerland in 1986 and presented *We take the B out of Banal*. I was taking a lot of drugs and drinking, killing live chickens. Tara, if I remember, was also a bit off her face. The performance took place in an old packed out cinema, and there seemed to be a never-ending rote of performances. Most of the town was there. The Lord Major was on one of the balconies, everyone was applauding, a chamber orchestra was playing. It was really late and I had been drinking and went for a sleep. I remember Tara kicking me at two o'clock in the morning, still trying to get me to do this performance. I told them to fuck off. "It's two o'clock in the morning, I've fucking had enough". But we eventually did it. It was actually the last performance myself and Tara made together. I was carrying my Geek situation to extremes within that performance, as much as Tara was working on the whole 'mad housewife' domestic situation. These two people who couldn't communicate any more, and that was the level of our

relationship anyway – not even having any great interaction on stage.

I was being offered a lot of commissions in 1987 and it seems now that I reacted really badly to being asked, and being paid money for these commissions. I was scared of the responsibility. I felt isolated, not part of a broader cultural activity. I believe now, in hindsight, that in the akshuns at this time I was perpetuating my own destruction; purposefully but not consciously beginning to tear everything apart at the seams. That I had begun to explore well-documented psychological states like a fugue state was probably an indication of where I was heading. People in a fugue state are constantly in turmoil, experiencing disconnected personas within their personality. Sometimes they wouldn't know who they were. I read of some case studies in which a person would move to another city and set up a whole new life without remembering their past. An amnesiac condition, volatile yet marked by an ability to somehow still function on a surface level.

Increasingly, I wasn't being kept at a safe distance from any audience – either for them or myself. Organisers of events didn't understand what I was doing. Akshuns became more confrontational and I crossed the line, invading the audience's space. I felt I was being given a licence to be abusive, and went with it; there was no one else there for me. On the *Fugue States* series I went on my first tour of Texas, in 1986. I felt that I had to move out and produce something somewhere where that type of performance activity was quite new, and Texas appealed to me. Working in England on some of these commissions seemed to me too easy; one became part of a performance art 'ghetto'.

NO POPE HERE ON THE FREEWAY

The *Freeway* tour was organised by Daniel Plunkett, who ran a small fanzine called *ND* during the early 80s that dealt with new music, sonic experimentation and performance. We had this little tour round Houston, Dallas, San Antonio and Austin, low key and quite inexpensive to organise. Younger audiences attended and that appealed to me. I felt supported, that there was an excitement about what I was doing and a willingness to engage with it. The *Fugue States* performance series consisted of a series of shifts through four separate personalities, or fugue states, within a basic structure, accompanied by slide and film sequences and a use of props. The music was by Paul Bowen and myself.

The first section, *Night Thoughts (Satellite)*, used nocturnal imagery as a backdrop to me covering myself in foodstuffs. The second section, *The Rationalist*, alluded to a desperate rationality, in which I explained the theory of relativity using the detritus from the first section as illustrative props. The third section, *S.O.B.*, featured the emergence of the 'monster' within. I fucked an inflatable skeleton on a podium, showering the space with mayonnaise and ketchup. The final section, *The Day I Woke Up (New Age Kamikaze)* continued the progression of alchemical lycanthropy, as I attached false limbs and joke tits to my body in an attempt to morph further. At the end I was chased from the space by a pack of toy mechanical dogs. The imagery, overall, was drawn from my formative experiences of American culture, television and pop art.

No Pope Here On The Freeway, 1987/1989

When I came back to the UK I made a narrative fiction from my Texas experiences. *No Pope here on the Freeway* was based on the idea of the Pope coming to visit Texas (which he had done at this point). For the prevalently Catholic Mexican population in San Antonio the visit had been a really big affair, so I used trashier cultural elements – plastic crosses and crucifixions, which referenced traditional religion's ability to subjugate.

The premise was a meeting of the Pope on the freeway with a convict cowboy persona who was sort of lost. I used fantasy from my childhood: of cowboy movies and particularly Montgomery Clift, in the film *Red River* with John Wayne, and the great cattle

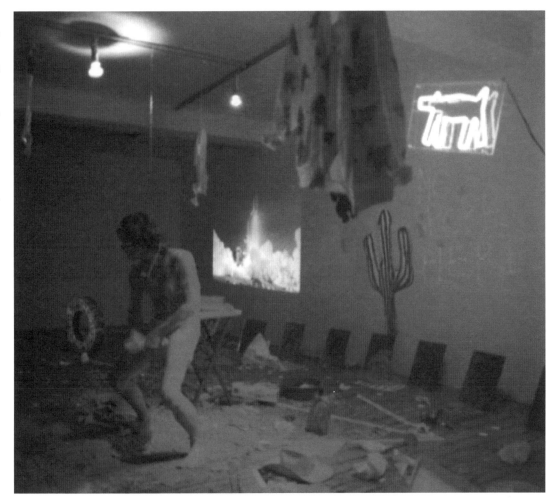

runs from Texas to Chicago. I identified with Clift in terms of his drinking and drug taking. The ambience of the performance was achieved through a use of heavy ultra-violet lighting, fluorescent strips, and projected road movies filmed while driving through Texas. I liked the idea of the road movie, the whole mythology of it. I was a tourist again, presenting an outsider's view of American culture.

Certain elements became highly sexually explicit within the performance. I used large phalluses, and masturbated with ketchup and mayonnaise. I was specifically referring to a capitalism offered by the United States; the manufacture of a broad view of consumerism that seemingly offers salvation for the individual. I find that problematic because it does the opposite, it creates a spiritual void. *Freeway* reflected the audience back on itself by literally placing mirrors at the back of the area, so that audiences were watching the performance and their own reactions as part of the whole. I think reflection is very important within a body of work – we live in an addictive culture and the problem with

any addiction is that we need more. In performance art what is happening in front of you is real and you're working with collective energy, constantly reflecting it as you move through the audience. The mirror has been fragmented and smashed by the hammer.

By metaphorical extension the body becomes trash, devalued by the culture, a site wounded and traumatised – not maybe in everyday life in a physical sense, but certainly in a mental and psychological sense. There was therefore an increasing eruption within these performances of a tough, hard sexual male-dominated energy. The vulnerable male member, my own genitals, would be eradicated, hidden behind a dildo that was always erect and hard and penetrating. The dildo was a mask that denied the possibility of impotence. I penetrated the trash with it as a pyrrhic denial; this rationalisation ultimately became violent and extreme. I was simultaneously creating regressive and transgressive states relative to adolescence, of different states of growth. My transition through the late 80s into the 90s was about breakdown and the possibility of a growth into maturity. Working as an artist you're always in process. The discipline was in the work that happens day in and day out: the research, reading, notations, taking notes, writing, drawing, making objects or elements in the studio and constantly playing around with configurations that will work.

Some of the aspects in *Freeway* – the kitsch iconography, references to cultural icons, cult religious practises, quasi-political movements such as the Klu Klux Klan – were played out over the next body of work, under the titles *Mysteries* and *Night Thoughts*, taking the kitsch iconography and low-fi

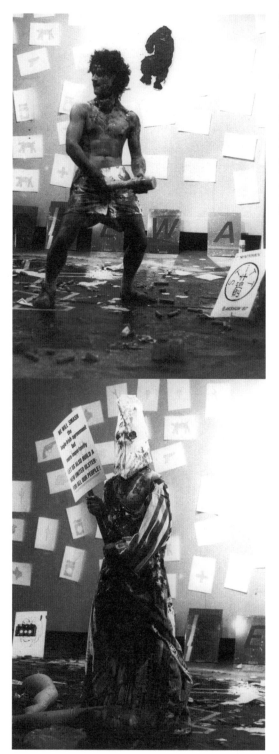

Mysteries II, Cambridge Darkroom, Cambridge, 1987

technology to extreme. Even though *Night Thoughts* and *Mysteries* may not have appeared on the surface to be particularly distinct in formal terms, the former focused on a fall from grace, and the latter the potential to emerge into the light.

The body – my body – was the engine, the centre of the energies unleashed, both as catalyst and conduit. You don't rehearse. There's a moment of infiltration and a moment of eruption into that environment. I am very vulnerable when I go into that, I don't know really what's going to happen. I have to have faith in the structure.

A binding iconography in both works was my identification with certain personalities such as George Best, Montgomery Clift, Edie Sedgwick, Keith Moon, Charles Bukowski, used as large photographic backdrops to the akshuns. Subversive cultural icons. Referring to them was like having an arsenal, where you could pick out of it at will what would be the most potent weapon and put it in the context

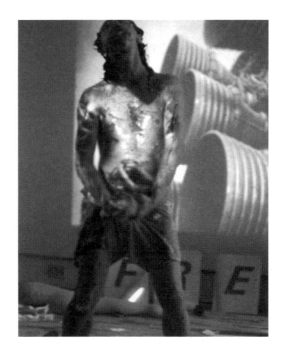

Night Thoughts, Cornerhouse Gallery, Manchester, 1987

as you wished. For instance, the reference to George Best was obvious: a great athlete, for my money probably the best football player ever, an alcoholic who fell from grace. Such references still recur and have significance.

HARDCORE ACTIVITIES

In 1987 I took part in a festival in Portugal with Tara and Bruce Gilchrist. I'd started to construct a dysfunctional automaton Trickster suit, with a large metal triangular mask. This figure was in a sense translated from Freeway and other performances into a very hard, masculine figure, hiding behind the metal mask. I had been working since the mid 80s as a labourer on building sites in order to support myself and my practice, which gave me first-hand experience of that sub-culture: drinking,

working, carrying out hard physical labour, reading the tabloids and commenting on the size of the page three model's tits. Unpleasant aspects of masculinity. The mask represented a hard exterior, but this facade gradually fell apart during a series of repetitive demonstrations of physical labour. I used a cement mixer to mix up consumer products and foodstuffs with building materials. I put a blow-up doll into the mixer, and the legs were whirring around as I shovelled more elements in.

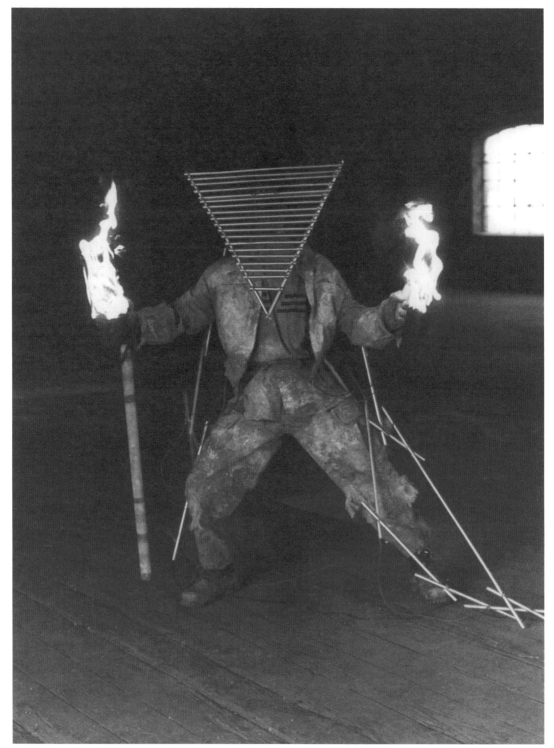

Covert Activities (AKA Red Herrings), International Conference on Sculpture, Project Arts Centre, Dublin, 1988

From 1987 to 1988 my performance activity was actually quite sparse, and I think that had a lot to do with coming through a long series of commissions. I had a sense of needing to re-evaluate, to try to make performances which were minimal, more direct, and had perhaps a single or few basic akshuns to them; that were repetitive to the point of exhaustion. In a performance titled *The Last Supper and the Dry Dive* in Paris I shot myself in the head and dropped heavily to the ground, repeating the akshun over and over again. I was trying to symbolically destroy the body but was unable to do it. I got to a point of no pain – or, at the very least in terms of the structure of the performance, a normalisation of pain. It appeared quite a ridiculous foolish akshun; it's not real, it's not a real gun, but at some point in the repetition it started to appear real.

At the same time there were also cartoon-like references to Popeye. I consumed large quantities of spinach – playing to an inflated macho caricature. The hard paramilitary style figure wearing the Trickster mask appeared again, metal rods on the costume acted as exterior limbs, eventually ripped off to expose the human being underneath. There were references to cleaning, washing, using heavy industrial detergents, washing the face, trying to eradicate vision, trying to rip off the mask of the face. The conclusion would invariably be the destruction of the performance site that had been installed so methodically. The area would then be swept and cleaned into a central point. All the food, vomit, wine, detritus, rubbish, trash, pulled together. I would strap my legs onto a little cart and become The Gimp: a person with no legs on a little trolley, a wounded human being, totally

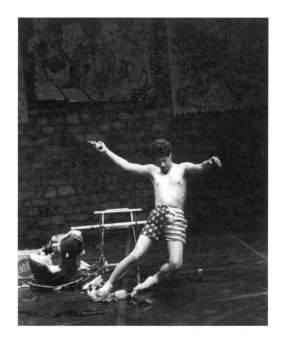

worthless, pouring ketchup all over his body, then proceeding to light a flare and hold it up in a Statue of Liberty pose. In total an image of the inadequacy of the capitalist system, an indictment of a community that could lose the ability to take care of its disabled or disenfranchised.

In 1989 I embarked on a tour across the United States with Tara Babel and another artist, Shaun Caton, producing two different versions of *Covert Activities* in Austin Texas and in Los Angeles. In between we made a number of different performances at venues from Texas through to California. It was quite a wild tour from what I remember, culminating in a group performance in Los Angeles at the Zero One Gallery titled *Boke Factory*. We set up a central tableau that the audience gathered around; a restaurant table in the gallery. Shaun and I were two waiters, wearing comical chef's hats, our faces distorted by being bound up in wire. Tara

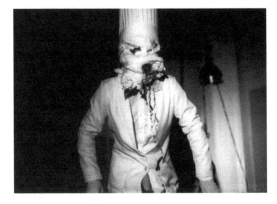

top left: poster for *Covert Activities*, Project Arts Centre, Dublin, 1988; right: *Boke Factory* (with Tara Babel and Shaun Caton), Zero-One Gallery, Los Angeles, California, 1989; left: image from *Covert Activities*, cover of *High Performance*, 1988/1989

was the guest, dressed up for a night on the town. Shaun and I behaved in a completely dysfunctional manner, drinking heavily and messily throughout the performance, vomiting, throwing hot dogs around the space and into the audience, covering Tara in ketchup, lifting up her skirt and lathering these foodstuffs between her legs. The audience started to get very involved, flinging

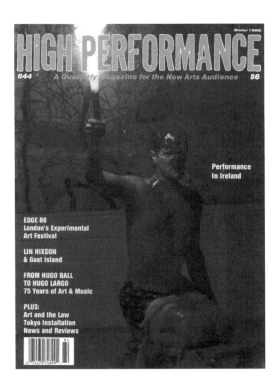

food and eating stuff, joining in with the chaos. Eventually it went right out into the street, the audience followed us from the premises. The last I remember was seeing Shaun up the street at a bus-stop being refused entry on a bus.

There were a number of occasions when I had to be taken to hospital. I was nearly blinded on two occasions when I repeatedly dipped my head into a bucket of detergent. I paid attention to the possible danger but in the middle of those performances anything could happen and did. There have always been minor injuries, but because of the energy in the performance you carry on, you become impervious. After performing at the Highways space in Los Angeles I was treated for damage to my eyes, after which I left still in my hospital gear and took a bus to San Francisco. I was blind-folded by bandages. Someone met me at the bus station and took me to the space. I walked in and created *Blind Man's Bus* with my back to the audience – as I couldn't see anything anyway. The pain in my eyes was raw so I had been drinking. I poured detergent all over the audience, I was flinging things at them. It occurred to me that I probably looked a bit of a state – I hadn't shaved for quite a while,

so I encouraged the audience to shave me with these cheap Bic razors. They had to approach me whilst I was chucking this detritus over my shoulder. As in *Boke Factory* people were willing to participate.

When I got back from the United States, Channel Four asked me to do a performance for a show called *Club X*. The premise of the show was an exploration of violence; the reality was completely ham-fisted, an excuse to show bare-knuckle boxing and the like. I didn't like those reasons and said that I wanted to question the nature of what constitutes violence, to manifest a carnival freak side-show on national television. The producers had lots of problems doing this, not only because it was subjective material but also because I wanted to do it absolutely live. I refused to have a rehearsal for it, although we rehearsed the lights in the basic positions, checked the camera shots. The actual performance did go out live, but they inserted a commercial break when things had got too much for them. At the moment in question I was covered in mayonnaise, masturbating, fucking a melon. I wanted to make a totally preposterous image. When they cut back from the commercial break they had orchestrated someone to speak about the piece whilst I carried on off-camera. We both knew what we were doing.

The next tour, *Baton Rounds, Butcher Boys*, in 1990, took in Vancouver, Seattle, Los Angeles and New York. I had begun to feel adequate enough to go back to exploring certain attitudes within Irish culture, a sense of migration, in order to achieve some sense of clarity about my motivations. This notion of travel was alluded to by moving through various virtual geographical locations constructed in the space as a form of cinematic narrative, utilising a series of musical pastiches made with Paul Bowen – well-produced but obvious parodies of contemporary cinema scores. The akshun started in 'Belfast'. I was banging dustbin lids together (an alarm used by residents to signal the need for the community to come out onto the street in times of crisis), drinking cheap communion wine and eating crackers, then throwing up, crawling on the floor following a series of battery-powered toy soldiers moving around the space. Spotlights followed the akshuns. There was an ambient soundtrack of Irish radio reports of the atrocities. This segued into 'London': I read poems about Belfast over a soundtrack of a heavy metal guitar being played very loudly. In the next section I wore a backpack, whacking oranges (the primary Unionist colour) into the audience with a baseball bat. I donned combat gear and Union Jack shorts, putting my hand into a bucket of ketchup and displaying a fist – the "Red Hand of Ulster", again a significant totem of the Protestant community. By the time I had arrived in 'California' I was wearing shorts and a hard hat, a hybrid parody of the Beach Boys, breaking up concrete with a jackhammer. A 50s cocktail soundtrack played, with dogs barking in tune, whilst I ate dog food. The akshun climaxed in the destruction of the site, in the creation of a theatricalised war zone. I was immersing myself in a paddling pool, romping around with a blow-up doll whilst a variation on the *Apocalypse Now* music was played. Smoke bombs exploded and toy helicopters whizzed round, as I finally donned the Trickster mask and exited the space.

ETERNALLY BOMBED

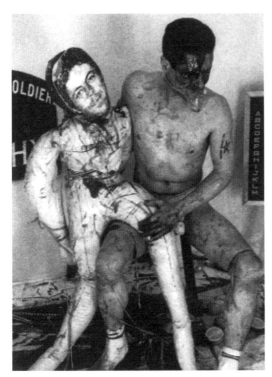

Romper Room, (AKA Did My Friends Have Fun At Play), Exiles Studio, London, 1991

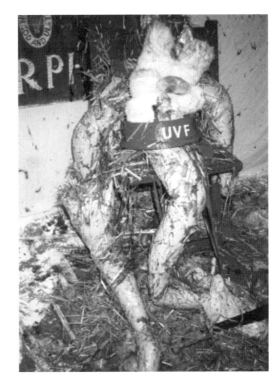

When I got back to London I was really broke, I couldn't get any building work. I'd met a girl in Vancouver and we'd got married and she had arrived to live with me. I was still drinking and drugging and I didn't really produce much work for the next two years. This was probably the worst period of my life. At this point I had a drug cocktail going in the mornings:a mixture of speed, amphetamines, methadrine and valium. I was starting to puke up and shit blood, but I was hiding all this stuff.

I found myself becoming increasingly obsessed with the Shankhill Butchers again. At this time I was in a psychotic state: I actually felt capable of carrying out a murder, and

formed an empathy with an imagined sense of insanity that must have existed between these men. Performing my akshuns was actually a way of staving off these feelings, of realising destructive acts within a controlled environment rather than surrendering to uncontrollable manifestations. Finally, I made *Romper Room*, a public performance around these themes, when I was invited to a synagogue at the Heritage Centre in the East End of London. *Romper Room* was the phrase given to the gang drinking den, lock-up garage or deserted house that the Shankhill Butchers took their victims to, before torturing and slaughtering them. In a cruel irony the name had come from a popular children's TV show.

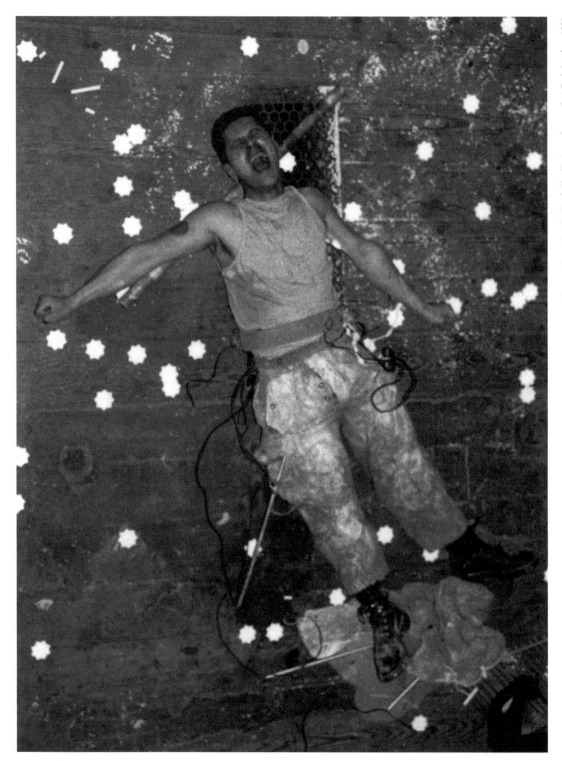

Romper Room, Eye To Hand, The Heritage Centre, East End, London, 1991

I have no recollection of the performance. I'd set it up, business as usual, I'd managed to install it, I was all ready to go. There was a big audience as I hadn't done anything in London for a while, so a lot of people were there to see me do the business. I remember downing two bottles of Thunderbird wine and that's all: the next thing I remember I was hanging over a sink washing my hair. I did the whole thing in black-out. I only have a series of photographs.

By the accounts of my friends and wife, I had an insane breakdown in public. I was throwing things into the audience, pulling the whole installation apart, destroying everything. There was no performance structure, no rhythm, no articulation, as in all the previous works. I simply shouted at and abused people in the audience. I cried. I dismantled the Romper Room.

A number of critics were there who had wanted to write about my work, but afterwards no one wanted to interview me. The fact that I had blown it completely was indicative of the behaviour of an alcoholic. I had an extremely low sense of self-worth, could not accept any level of success and so had to destroy it. There was a strange sense of logic to becoming a failure; one could actually be quite self-righteous about it.

I began to make private akshuns as a way of helping me to re-assert myself. I could not do the performances in public because I was terrified how far I would go in such a context. I asked a photographer, Tony Clark, who used to be in BMUS, to help me document the akshun. The akshun we produced fed into one of the few performances I did that year, *Tit Fer Tat*, in 1992 at the Sheffield Expanded Media Show. *Tit Fer Tat* references one of

the justifications trotted out in defence of Sectarian killings: the "this for that, me for you, an eye for an eye" mentality. The akshun was similar to *Romper Room*, in that I flagrantly abused the audience, was actually fighting with people, throwing things at them. I abused a doll-like body which had a photo of Lenny Murphy – the ringleader of the Shankhill Butchers – on the head. Fucking Lenny Murphy, sticking things in Lenny Murphy's every orifice, trying to get right inside the body of Murphy, to pull out the guts, pull myself out from this body and my own body, from this vehicle that I had been walking around in.

Finally, in the summer I presented *Hot Dog* at the Exploding Cinema. This was the cathartic akshun that most totally indicated my state of mind, the repugnance of who I was in a public context. It was shown at close quarters, with a backing track of heavy rap singing the lines of porn magazines. The atmosphere was one of a debased sexuality. I shoved a lot of implements up my arse: scissors, a broom handle, a gun, stilettos, a German sausage. Whilst some sections of the audience were horrified, shouting for me to stop, others were goading me on, screaming "go for it". I was stuck in the middle of it all. I was dead inside. A sense of nothingness, but tempered with extreme pain and terror.

I was lost in the addiction. The only comfort I could get was when my head had stopped thinking – and the only way to do that was to drink, to black out, then do drugs to anaesthetise myself further. I was unable to go out unless under cover of darkness, sitting with the curtains closed. I was living in a large squat in a block of flats and invited all sorts of people in. Sitting in a corner crying as

people were walking in, other junkies taking my possessions and walking out, with me incapable of doing anything about it. Lying in my own blood and piss and shit and vomit, not being able to wash, not being able to change my clothes.

Then on 17 November 1992 it just stopped. It seems difficult to talk about such a thing-maybe because I had a mystical experience, which is outside of the experience of most people. I was lying on the floor in the squat, on this hard wood floor. I felt like I was dying, the whole essence of who I was was draining bit by bit out of my body. I remember feeling this incredible whoosh of energy, of going down a tunnel into an incredible bright light. I had a feeling of absolute perfection, which to this day I can still access. I had never experienced such a feeling in my life. No drug, drink, sex or anything else had ever had that impact upon me. That was the last thing I remember.

I came to about 48 hours later, simultaneously confused, excited and terrified. Something had happened but I couldn't comprehend it. I remember walking outdoors and my senses working again, breathing the fresh air. It filled my lungs. I knew from that point that things were going to change.

By this time my wife had had enough and had left me. I decided to actively get help, and spent an initial five-month period recovering, part of a process that has continued on a daily basis. My rehabilitation not only involved formulating a dietary regime for my body, but also learning to interact and identify with other people – a process diametrically opposed to the macho facade that I had projected in the akshuns, but which also related to the vulnerable underside that had also been evident in the work. Gradually, bit by bit, my life came together again. I acknowledged that I could no longer safely drink at all. The sense of power that alcohol and performance had given me was false. I discovered that real power came from a sense of humility, of not having to fight life.

FEEL GOOD

In May 1993 I was able to make my first new performance. It took a while for me to be able to have the courage to do that. The decision was, overall, an intuitive one; daily living wasn't enough to project my long term fears on to. I needed to find the ability to interact socially.

Nosepaint, a group who ran regular art events in Vauxhall, London, were producing *Woodworks*, a series of events targeting the community and history of that area. Their invitation to me provided the opportunity to make work in a non-solo format, and I produced two pieces. The first was *Poopscoop*, a simple akshun carried out over a number of days. I cleaned up the dogshit in the gardens and left a little card symbol with each piece of dogshit that had been littered around the park. I was able to interact, to talk to local residents about the dogshit problem. We had conversations. I became interested in people other than myself. A feel-good performance.

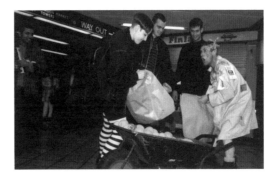

left: Poop Scoop logo from *Poop Scoop*, Woodworks, Spring Gardens, Vauxhall, London, 1993; right: *Geek Shop*, Woodworks, Vauxhall Underground Station, London, 1993

In the other piece *Geek Shop* I re-enacted the Geek persona. Surprisingly, I had no difficulties in re-enacting the Geek – there was no underlying pressure to prove anything. The Geek had a free food shop, and gave out free food from a wheelbarrow, haranguing people in a tube station. It was manic but good-natured. The confrontational outbursts in *Geek Shop* were Tricksteresque; they would suddenly turn absolutely silly and people seemed quite terrified of me running toward them, but then somebody would break into fits of laughter when I would do something absolutely ridiculous (I only made one more Geek performance, in Glasgow in 1994, and that was it, you know. Rest in peace. It was over. I had no more use for that persona.)

After those first exploratory performances, I felt like I wanted to move somewhere to try and reconcile some of the aspects of my breakdown with a new direction. In 1993 I embarked on another Texas tour. I didn't want to do any of this work in London, which I considered to be my secure 'locality'. I wanted to be in a 'frontier' place. I asked artists Bruce Gilchrist and Clare Pritchard if they would like to come along and make a small tour around Houston, Austin and Dallas. We did a series of shows together, several pieces all in the same night. I began to focus on some of the aspects of previous akshuns. I didn't know if I could deal with them but I felt I had to try. *Gridlock* re-introduced the Trickster persona in order to understand whether the fool was actually wise. I made a hard akshun, to exorcise previous times; something archaic and primary. I had a special harness made with a shrine shelf unit built on to the back of it. There were lots of implements, relating to torture and dissection, hanging from the back. I skewered myself with these implements – a long wooden pole attached to the altar by a chain – trying to understand what the earlier anus probing had been about. The traumatic nature of the akshun was counterpointed at the end of each piece by the organisation of a feast. The audience was invited to partake of a range of exotic tropical fruit, sitting underneath a neon sign which spelt the word HOME. My intention was to create a community of sorts – a concept wherein one could 'come home' and share under the shadow of the past. I felt that home was everywhere; that in the moment of

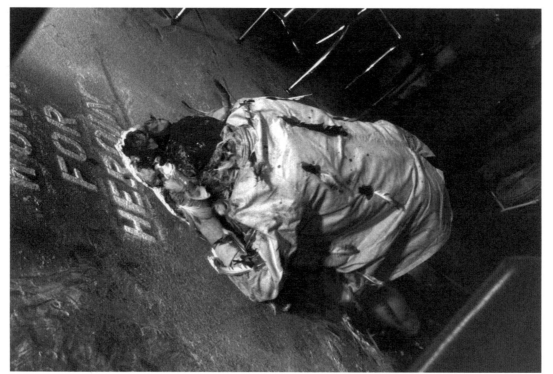

Gridlock (AKA I Will Work For Nothing), Electric Lounge, Austin, Texas, 1993

the akshun we were the beloved of the earth. It was as simple as that.

I also presented *Gridlock* in Brighton and Rotterdam, this time utilising a latex triangle as a central element. Unlike the latticed triangular mask that I had used in previous works, this triangle was more feminine. I alternately stuck my head and fist through it: suggesting a way of finding a way to the feminine side, of going back to the womb. Nevertheless, the akshun was still a violent one; there was still the potential for debasing such a primal urge. By extension, I was taking things one day at a time.

At this point I wasn't actually doing many performances. I was still in a process of consolidation. In 1995 I was invited to Cardiff Art In Time and produced *Crow* for Chapter Arts Centre. The Crow was another variation

on the Trickster persona. There is an old Buddhist text that reads "Life Is Easy For One With No Shame", so in parallel to my process of recovery the performance attempted to move towards something fresher and clearer, something transcendent. My father had just died and I'd returned to Belfast and met my family, and we had come to terms with my abusive behaviour. There was a feeling of letting go of that. Also, by this time, the divorce with my wife had come through.

I extended this feeling of personal closure to the structure of the performance. How does one actually finish a performance? For instance, it would have been easy to carry out a traumatic akshun and then just leave the space, with questions hanging enigmatically in the air. I wanted to question the whole nature of this: the pact made between

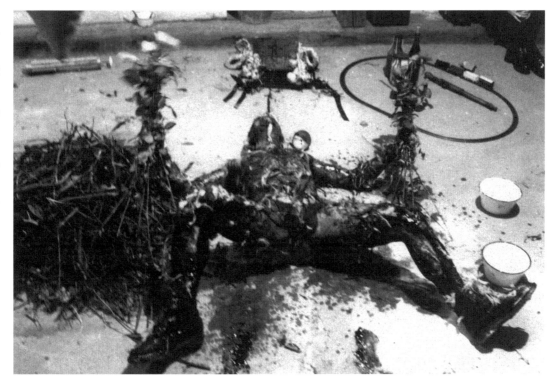

performer and audience, the prevailing idea that "here we are, a part of it, yet we know that it is just here and were are safe. We can walk away, we don't have to really deal with it later". Which was fair enough but I wanted to talk about it, which was unheard of in a performance context. I wasn't sure whether it was going to happen or not, but I had the technicians prepare a microphone, a table and a chair, just in case. At the end of the 'performance' element – in which I had adorned my body with molasses, then added feathers, so in effect I was being tarred and feathered, marked as a potential outsider – I sat at the table and talked quite calmly to the audience for ten minutes about what I'd been through in my life, and the experience of the last couple of years. It was unscripted, but I knew that I wanted to talk about the nature

of community. "At this moment we're all here, we're community right now, this is what we accept. There are reasons whey we've all ended up together at this moment and there is an element of taking collective responsibility for that." I ended the piece by chanting a poem by Gary Snyder – *Spell Against Demons* – and that was it. That was the 'real' end. A few artist friends who had seen my work over a number of years were angry about that. A lot of people hated it. Some people commented that I had in effect taken the performance away from them, which I thought was interesting. I didn't agree with that. I think I made people more implicit in the work, who seemed more shocked by this than the previous mayhem. Some averted their eyes, maybe slightly embarrassed about what I was talking about. It was an absolutely

wonderful moment, and I still love it. It was a real Trickster moment; everything was turned on its head.

I made a second *Crow* work in Galerie QQ in Krakow in 1995 on my first visit to Poland. The Crow in mythology is a mischief maker, so my idea was of the mischief maker learning to fly and attempting to break free from man-made systems. I was covered once again with molasses, a resonant substance for me: it's sweet, dark and sticky, suffused with primal associations. I had a rope ladder and

at the end of the performance I climbed to the roof of Galerie QQ, but of course I couldn't get out – I was stuck in the rafters. There was nowhere else to go.

My work since 1995 has been concerned chiefly with a plea for, simultaneously, greater freedom and greater accountability and, by extension, our relationship to not only political but also natural systems; the relationship that we have as human beings to a greater ecology and a holistic understanding of our communities.

SECOND SKIN

Second Skin came directly from my experiences in Poland when I had travelled to the extermination camp at Auschwitz Birkenau and visited people in the old Jewish quarter in Krakow. When I was being taken around these buildings I noticed that they all had these ancient bathrooms with old baths. It felt like the history of the place was embedded in these surfaces; there were overpowering associations of tortures having taken place in these bathrooms. When I got back to London I started reading Holocaust literature. This was a contentious area to enter. It was perceived as belonging to a dominant Jewish culture. I had difficulty in trying to understand my relationship to something that was so loaded. I identified with it on a basic human level – I am not saying I could identify with the experience as there is no possible way I can, except perhaps through a removed experience. I talked with Jewish friends in London and visited Rabbis, corresponded

with artists who were working directly with Holocaust material.

The subsequent akshun – again presented at the Cardiff *Art In Time* festival – was a simple one: to chip all the enamel off an old bath with a hammer and chisel. I confirmed the ritual aspect by using sage as a cleansing element within the performance. Sage is a common medicinal material used specifically in both ritual and domestic North American cleansing, but also features as a medicinal property in a number of cultures. I used a smudging stick, burning it and wafting it around the space as a way to trigger a physical leap from the preparatory meditation prior to the akshun to an embodiment of the physical act to come. Both ritualistic and mundane, it is a way by which I continue to make a site 'specific'.

People were able to come and go as they pleased. The site was a cold stone room. The sound of the chipping echoed, amplified

Second Skin (Behind the Mask), NIPAF, Japan Foundation Forum, Tokyo, 1996

exponentially into something physically painful to the eardrums by use of a contact mike attached to the bath. I was trying to get under the skin to the 'truth', to expose something, in the process breaking down parts of my own psychic armour. The duration was protracted and the materials much sparser than in previous akshuns. I tried to find some compassion for myself and by extension others, scrubbing and cleaning the bath. I was crying.

After the Cardiff show I was invited to The Japan Foundation Forum, a big theatre complex in Tokyo, to participate in the NIPAF Festival, and also made a subsequent performance in another big space in Nigano, at a prefectural cultural workers hall. These performances were an extension of *Second Skin*, sub-titled *Behind The Mask*. The Trickster reappeared, again a masculine warrior-type paramilitary figure, who this time became the 'interrogator' of a Japanese bathtub. The bath was a vacant receptacle for the body, had the connotations of the body. I carried out a series of explicit and perverse akshuns upon the bathtub: pissing in and on it, wearing a dildo and forcing it through the plug hole, coating it in oils and setting fire to it. I was thinking about being in that position of interrogator; it must become too much to handle. You are stripped away of your dignity as a human being by the actions that you are ordered to carry out. Is there a fracture at some point, where you actually break down and your humanity is revealed? What happens then?

MAGICAL BOTHY FOR GHOSTS

In June/July of 1996 I undertook a residency at the Baltic Art Centre in Ustka, North Poland, a wonderful opportunity to go away somewhere quiet and work. One of the first performances was in an event called *Castle of the Imagination* in Bytow. I used the site of an old heating room under the castle, which had a steel catwalk raised above all the old heating appliances. There was a strange energy to the place, which had originally been used as dungeons. To me the site became symbolic of the sub-conscious, so the akshun was called *The Secret Place*.

I was researching religious traditions – or, rather, spiritual traditions – becoming interested in the works of the New Testament.

Shelter, Smolinski National Park, Baltic Region, Poland, 1996

The original metaphorical reading embedded within these parables has perhaps been lost by contemporary literal interpretations, which seem to leave little or no room for imaginative readings. A passage that struck me was from Psalm 91: "He that dwelleth in the secret place of the most high shall abide under the shadow of the Almighty." The place of the most high is your own consciousness, hence *The Secret Place*.

People initially found me in the dark, smudging the space. I had hung cans of animal blood through holes in the catwalk. These were pierced so that the blood flowed out over me. On the catwalk, raised 'on a higher state of consciousness', was a set of three video monitors depicting slow camera pans into fields of blooming flowers. At the end of the performance, I moved up from below, walking along the catwalk wearing a coyote skull, blowing a train horn (echoing a common experience of dispersion within Eastern Europe) culminating in the whole catwalk being set on fire in a ritual cleansing. The utopian images of the flowers were not real, merely a simulation. The dystopia is still a reality: the borders still change and the power struggles continues; World War One becomes World War Two, becomes the Cold War, becomes fractured tribal conflict.

I walked everyday in the woods near the Baltic Art Centre, creating little rituals along the way; building shelters and leaving the trace elements, not unlike earlier akshuns such as in the church in Belfast, but in a wider natural setting. Often when I arrived in remote areas within the middle of the forest I thought something strange had happened there. I often wondered, in my imagination, what bodies were buried here. Some areas

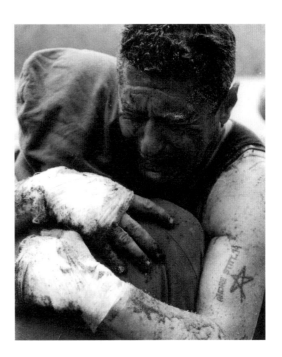

just felt wrong. The shelters were a way of providing refuge and comfort for whatever spirits might pass.

I made a long road trip from the top of Poland over to Transylvania, to an environment besides a wonderful lake, St Anne's Lake, by an extinct volcano, to participate in the *Annart* festival organised by Gustav Uto. In my personal experience of travelling I have an acute sense of crossing time. Time sometimes doesn't exist, it becomes thin. I can often feel the reverberation of something that has happened in a place. This was an occasion when I felt that connection. *Europe Endless* was an indication of the history of Europe, the endlessness of political negotiation of land and the cultures within that. All the elements were totally right. Magic happened in certain moments of this performance.

Prior to the crowd arriving I had buried elements in the earth taken from a Russian

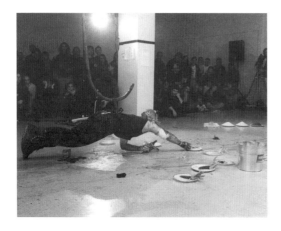

Ceasefire (Make Sure You Have Bread On The Table), Recontre internationale, Le Lieu, Quebec, 1996

Army base near the eastern German border. It was the size of a whole town yet hidden in the middle of the forest. When the Russians had demilitarised the place the inhabitants had moved out within a couple of days, literally leaving everything. There were nuclear bunkers and missile silos, apartments left with soup plates still on the table, people had been ready for dinner, there were still plants on the walls that had died. Apparently they'd left all their guard dogs and these packs of dogs had then escaped, roaming the countryside attacking people.

I was dressed in black combat gear, digging up gas masks and weapon cases, domestic pots and pans, old coke bottles and Polish alcohol, abandoned family photographs. I repeatedly ran to the lake, shouting "Earth Spread Your Legs", carrying the elements and hanging them within a triangular structure consisting of a series of crude crosses. I covered myself in molasses and feathers, daubing the words *Europe Endless* on a large white sheet, lighting flares and blowing a train horn.

There was a large crowd at the performance, and at one point I felt myself pulled by some energy towards a young girl,

about sixteen years old. I started weeping and I got down in front of her. I was holding her, hugging her and she was crying as well. After a period of time I remember letting go, looking at her and saying "it's going to be OK, isn't it?" and she looked up at me and nodded. It's never too late if we are prepared to take responsibility. That's what can happen in performance when all the elements are there exactly at the right time. You don't have to say anything more. That's it.

This situation happened again – where the energy really changed in the performance – in a work presented in Canada called *Ceasefire*. The title was a direct reference to Northern Ireland, which at the time was going through a significant phase of the peace process in which both paramilitary sides were pledging to uphold a ceasefire, but I also wanted to make a more universal reference with the work. The iconography of elements that I was using had by now become my own; although sourced from certain cultures they are in fact universal. They don't necessarily wholly belong to one custom. In Quebec I wanted to use an eel in the performance, something between a snake, a phallus and a fish. I had asked the organisers to supply a dead eel, but when I lifted it out of the box – literally just five minutes before the performance – it was alive. I didn't want to kill it, yet there seemed to be no other possibility; it couldn't have been returned to the sea and would have died anyway in the short term.

The performance, organised by Le Lieu, hinged on the idea of being caught in between things. I hung from a large hook from the ceiling. Bread was impaled on the hook, and treated with oils and sacraments. The eel became part of this sacrificial aspect. I

chopped its head off. It was bleeding all over the space, and I was down on the floor with it. I felt a pull of energy towards a woman who had been standing in the audience. The rest of the audience had stepped back one row, and she was left standing just in front. She was a large, strong woman. I started hugging her, leaning into her and listening to her stomach. I thought she was pregnant because she was such a big woman. We were both crying. I subsequently learnt that this woman came from a fishing town somewhere up the coast, and had never been to a performance event before, and was transfixed by the ritualised content of the performance. The performance ended with me smashing through the back wall of the space and making my exit.

The Toronto version of *Ceasefire* explored a dynamic between private and public, with a family dining table as the central element, with childhood household photographs of myself and my ex-wife attached underneath. I swung the table into the air from a hook, giving a fleeting view of the photographs. The subtitle – *Make sure you have bread on the table* – was indicative of the table as a place for communion but also of interrogation. Many families experience this on a daily basis. The table was attached to my arm by wires. Bread was nailed onto it, but I couldn't reach it, so I eventually started to chop the table up with an axe, using my free hand in a motion that threatened the restrained hand. I knew in advance that my ex-wife was going to be in the audience. The akshun ended when I gave her my ID tags, which we had previously exchanged at our wedding ceremony.

GOD IS SEXY

In 1997 I was commissioned by Franklin Furnace to produce a performance anywhere in the city of New York. I thought "well, why don't I do a street piece?" This was the first occasion that I had been back to New York since my bad time there in 1990. I wanted to do something lighter, something with the public in some way. I made a large placard with the legend "God Is Sexy" on it. I do have a deep faith in a power greater than us all, something resident in the universe that one might call 'God'. God is unconditional love. For me God is sexy. Nature is full of sex.

I used a certain type of retro-nostalgic writing on the board. I liked the idea of just walking up and down Broadway all day. I could have been any old weirdo. Talking to people, getting out little buttons with "God Is Sexy" on them, giving out these little religious tracts, a series of proposals in terms of what a community is. It was a fun piece. Initially I started making the performance with a loud hailer, preaching "Brothers and Sisters, God is Sexy", but then the police appeared almost immediately and told me that I couldn't use it. It was OK to say "God Is Sexy" on the street – but I couldn't really annoy people. Which was fair enough.

On a personal level I created discrete actions at various spots which had relevance for me. I had a series of photographs which had been taken during previous visits to New

God Is Sexy, Broadway, New York, 1997

York – pictures of me misbehaving and crazy – and I tied these to lamp-posts, rubbing in salt and oil as cleansing agents and just left them there, making a ritual exorcism at each spot. I was making my peace with a place that I had often been fearful of. Subsequently I've visited New York regularly and it is now one of my favourite cities.

After that I went to Baltimore to visit Al Ackerman for the first time since 1989. He had gathered a group of younger artists and writers who had a regular performance venue at the Wig Club. I made a simple club-style performance, taped a self-help literature book to my head in an ironic jibe, ranted and raved about healing your life, expanding on the preacher role from *God is Sexy*. I set my shorts on fire, which triggered the fire alarms

in the building, which in turn caused the fire department to investigate. I remember that the fire chief was none too pleased (he went for me with his fire axe). I couldn't stop laughing.

After Baltimore I went down to San Antonio. Jim Cobb, an old friend and brilliant painter, set up a performance with some members of the San Antonio artist's collective in an old Chinese general store that had been founded by immigrants at the turn of the century. It was a strange old building; whilst the upstairs had been turned into a club, downstairs was a large cellar with a dirt floor. I again used photographs from my family history – of my father, laminated and embedded in a large block of ice, wrapped in a shroud and roped onto a little children's bed. I smashed the ice over the duration of the akshun, set it on fire, exposed the memories held within the structure.

In the summer of 1997 I produced *Burnt To Fuck* at *Amorph!*, a transient performance event in Finland, located that year in Tampere. The organisers proposed using the city as a space, so I chose to use the streets, starting at the town square where they had all the flags of the participating nations in the festival. I positioned myself under a large Union Jack, lowering it to half-mast to denote the start of the performance. I didn't have permission to lower the flag. It was an ambiguous act, partially referring to the possibility of change in Ulster at that time, but also to the demise of British colonialism in Ireland as a whole. I wrapped a table in a white shroud, dragging it through the town to a more bohemian quarter on the other side of the city. The table was again symbolic as a place for meeting, either for communion or interrogation. At

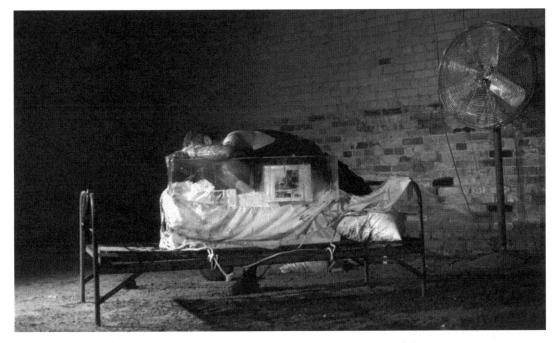

the second site I covered the table with blood, cutting a square out of the cloth and erecting it as a bloody flag. On the bottom of the table I had a picture of myself at about three years of age, running down a hill brandishing a stick in the Seymour Hill Estate in Belfast. I smashed the table and set fire to it. A public address system played a repeated loop of an RUC police control being told there was a body discovered at an intersection on the road.

TOWARDS A NEW COMMUNIONISM

In September 1997 I participated in a project at the Fire Station Studios in Dublin, situated in a bad inner city area. The previous summer a number of children had died of overdoses. There was a heroin epidemic and no one really wanted to do anything about it. The local community had formed vigilante groups to evacuate the local pushers and dealers, but there were still problems; if you wanted drugs you could get drugs and there was always someone around who was going to push it. This tight-knit community was being destroyed.

Artists were invited to produce works with the local community. There was a lot of dialogue, at the very least an attempt to gain trust, realised through a series of group meetings with both members of the local community and the local vigilante groups. People were of course initially suspicious of anyone coming in. The members of the project who had initiated the event knew

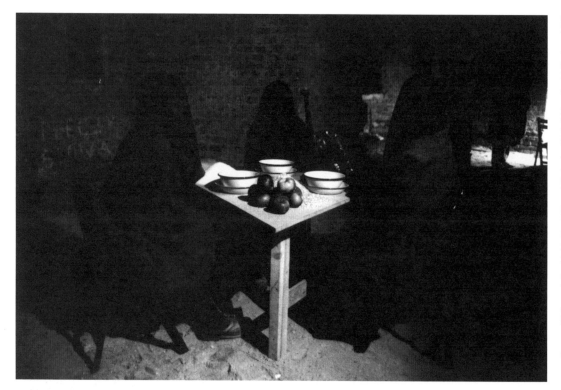

Harvest (24 hour akshun) (with Kate Ellis and Catherine Waller), Fort Sztuki, Krakow, 1997

something of my history, so there were obvious reasons why they had asked me to come. I had a number of, in turn, traumatic and delightful meetings with residents, during which I told them exactly what I was going to do. The akshuns were not open to negotiation but I wanted them to understand where I was coming from. I talked about my family background, my addiction, my feelings about recovery – not only for the individual but also for the family as well. I met many addicts during this process.

The akshun revolved around immersing pristine white sheets in blood and then trying to clean the sheets. Around this time some of my performances were subject to interesting accidents. For instance, I was using an old washing machine, washing and scrubbing the sheets in hot scalding water. Something

tripped in the building and all the electricity went off. I found out later that this occurred at the moment I had just turned the machine over. If I had touched it I would have been electrocuted. Whatever had caused it was fortunate, but also created a situation where the whole building was silent and in darkness. I proceeded to talk to the audience further about my experiences of addiction, a close and emotional encounter that opened up a new dialogue. It's important that artists can be seen as a healing agent. The most potent face of public art is to present a proposition with humility and respect, with dignity afforded to the community.

I had been invited to a large event in Krakow at St Benedict's Fort with a number of artists working at the same time. I had recently met Kate Ellis – who was present as

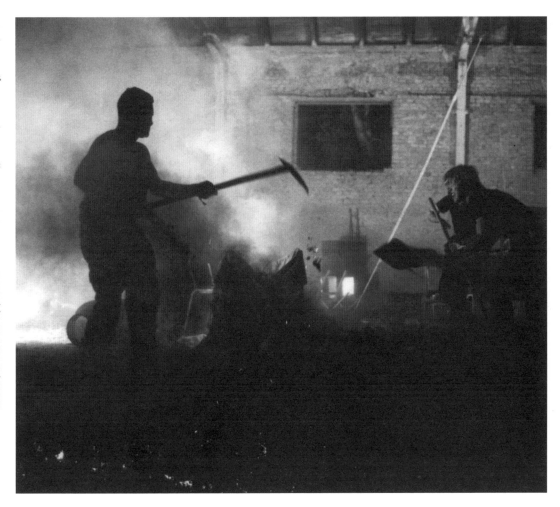

a student at the *Crow* performance in Cardiff in 1995 – who had started working with another artist, Catherine Waller. They had become friends whilst travelling together in Thailand, both professionally qualified Thai massage practitioners involved in meditation practice. I had been to see something that they had produced about relationships between women, and thought that they were going to psychic and physical spaces in ways that I hadn't often seen in women's performance work. I suggested the possibility of working together, so over the summer of 1997 we talked through ideas and got to know each other.

With *Harvest* we decided to see how one performance could relate to another, starting with some basic presumptions about what we were going to do, what sort of materials we would like to use, and what the relationship would be. The first piece took place over 24 hours in Krakow on the Autumn equinox from 6pm to 6pm. We used a cockerel which started to crow at daybreak. The three of us were seated around a triangular table, in one of many rooms in a circular fort occupied by

Communion, UKS, Oslo, 1997

artists making simultaneous activities. The structure was intuitive: sometimes slow, collecting food as a source of energy onto the table, sometimes it erupted in power shifts between the three of us – two of us would gang up on the other, then one of us would shift allegiance, starting calmly and then becoming increasingly becoming violent and aggressive. At other times the akshun would revert to a state of meditation around the table, as we attempted a mute psychic exorcism of shared elements within our families that we found uncomfortable. Large oil drums were set alight as beacons. We worked through the night until the next day. A visit on the day before the performance to Auschwitz Birkeneau produced an underlying motif which we subsequently used: a series of enamel plates and bowls and cups.

The second performance, for *Transart*

Communication in Nove Zamky in Slovakia, was a more condensed version of some of the prior events, a 40-minute work structured for an audience. The organisers had arranged for artists to make performances in official and semi-official spaces. We insisted on having somewhere different, so they procured an ex-Russian army base. We had been told stories that at certain points during the Russian occupation people would look out of their flat windows and see soldiers being shot in the courtyard. We used the energy of these stories around an idea of ritual and communion, again around a table. We each brought our own personal elements. Kate was involved with a sensual quality of the fruit; the sustenance of apples. Catherine was involved with bread; the making of it. I introduced an element of blood. The food, the destroyed table, the enamel bowls were all wrapped up in the tablecloth, which was then covered in blood. Kate and Catherine carried the shroud and its contents as if it were a body bag, whilst I laid out three pristine children's t-shirts on the back of three chairs.

By the third performance in Budapest we had started to find our own visual language, a symbiotic and intimate way of working together, in part a result of travelling and living together, spending time in discussion in hotel rooms sharing emotional moments. We were dealing with transitions from childhood to adulthood in terms of our own personalities, and, of course, in terms of this idea of a relational triangle between two women and a man. In Budapest we didn't want to do the performance in the Museum of Modern Art; fortunately we ended up at Art Pool, a new concrete, bunker-style space under a large city block. The process of

reduction from the first and second akshuns was continued, leeching out elements such as the table until all we had left was the concrete space and a few personal elements that we could carry at one go: bowls, cups, necessary for basic survival. The space was soiled with charcoal, oil and gold paint, then cleaned and scrubbed down around a central post. It ended in us washing each other's feet in a loving akshun, paying homage to each other. We wanted to create something positive and came up with the idea of harvesting as a way to bring people in.

After that, in Hull, I produced a piece at the Ferens Gallery as part of the *Rootless Festival* that referenced the Titanic (by coincidence at the time in the news because of the movie). The Titanic was built in a Belfast shipyard that a lot of my relatives had worked in. The 'Titanic' in the performance was a model embedded in a block of ice. Ice and coal in particular were properties specifically related to my environment in Belfast; growing up, the coal fire, the hearth, gathering round it for warmth, contrasted with a use of coal to propel the Titanic, the industrial product. These elements were bound together in a white cotton sheet and there was a sense of giving birth to this, ripping it open and letting it loose.

It was one of those situations, however, where nothing seemed to work in the performance, I had specifically requested a school choir to sing "The Red Flag", but they pulled out on the morning of the performance. In another one of those interesting accidents the various liquids and materials from the performance had seeped down the back of a purpose-built platform into all the electrics and tripped the circuits in the building. I was left stumbling about on this platform, which was at an angle – it was difficult to move over all the oil and blood. For a few moments I had gone out of the performance, found myself walking around. Someone handed me a torch and I just started speaking about the nature of what constitutes community. As in *Crow* we were here and we were in the moment. It may not have been an accident as far as I'm now concerned. I just said "we're here now, this is the community, we agree upon this, after I count three we're all going to shout at the top of voices as a manifestation of community", and as I counted three the whole of the place erupted and at that moment the lights went on. An absolutely perfect moment, to see the joy and comprehension on faces. The title *At Climax* was derived from the notion that in a natural state the environment at any point is always at climax: if not it cannot sustain itself.

To continue with the idea of birthing, I made *Communion* in Oslo at the UKS Gallery, which referenced children in positions of extreme danger or trauma. This was sparked off by an article I came across in a magazine about racial cleansing by Nazi doctors in Austria during the Second World War. Eugenics experiments. Doctors would gather together mentally and physically disabled children, and put them to death. There was an eventual public exposure of official records from one particular hospital; they would inject the children with strains of viruses to appear as a natural death, but perversely the Nazi regime – being what it was took – great care to keep records of these activities. I saw a picture of a young girl called Ingrid Weiss, a young child in real trauma, who had been injected. That was the starting point of the

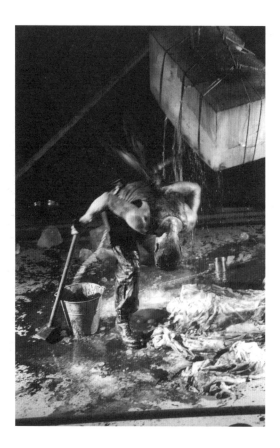

Winter Light, Kunstfabrik Torl, Cologne, 1997

performance. The official record, in English, stated that Ingrid Weiss was "life unworthy of life".

This also had a correlation to my relationship with my younger brother Michael, who is autistic. I used photographs of my younger brother and of Ingrid in the akshun, mixed with ice, salt and coal. These elements give me strange feelings about times in my life: the feeling of ice on streets, of ice turning to slush, making something dark and dirty and cold. Then the idea of the heart of the fire, the centre of the family activity. When the ice melted I removed the photographs and placed them in perspex frames, creating a small tableau. At the end of the performance, I carried out a violent

repetitive akshun, ringing a school bell. The bell marked not only a sense of closure, or mourning, but also of liberation: "School's out. Off you go." The sounds in the performance were minimal, denoted by variations of a single tone. I used a minimal ambient soundtrack of a submarine underwater. A feeling of being under something. The use of [the photographic] material in the work was done with the utmost of respect for the sanctity of life, especially to the person who had been Ingrid Weiss.

In the winter of 1997 I produced a series of performances, *Winter Light*, organised by Boris Nieslony in a number of German cities: Cologne, Dortmund, Dussledorf, Essen. There was more or less the same physical structure in each performance: a large scaffolding construction holding a huge block of ice. We had a team of trucks to carry the ice and set it up. Different elements were embedded in the ice-white shirts, photographs of friends who had died from AIDS and addiction – which was smashed, set on fire, and the photographs liberated from it. In the last performance in the series in Dortmund I daubed the slogan "Surrender" in animal blood on a wall, a sense of surrendering to the trauma of past experience, but also a sense of being part of the season, moving from autumn to winter. Autumn has always been a important time for me; it's a time of decay. There is a quote by Ingmar Bergman: "Whatever happens to you in your life, you hold your communion". That was the focus. Yes, things change, but it will be okay if we do the right thing. If we have faith and patience and love and compassion. Not only for other people, but often we forget to have compassion for ourselves.

A YEAR OF LOVE

I Love You, Sub Versions, Nottingham, 1998

In 1998 I took part in an artists' initiative organised in Nottingham for works in and around the streets. The work was scheduled for St. Valentine's Day, and I had been thinking a lot about love, how one talks about love. I made another placard, as I had in New York, with simple writing on it "I Love You". I walked through the streets of Nottingham with the sign telling people how much I loved them and giving out little badges with "I Love You". I prepared myself by meditating weeks in advance on the nature of love. I wore a cuddly synthetic fur coat. People really got into it, it was really well received, there was interaction. This was on a busy day, a Saturday. Lots of hard men were walking around, wearing T-shirts in the cold weather, freezing. I was telling these hard men how much I loved them and they all seemed to really appreciate it, which was quite astounding. There were lots of couples strolling by; I give them badges and then a kiss and a hug. I designated 1998 the"Year of Love" in terms of my art activity.

The Enemy was part of the Intermedia Festival in Cork in Ireland, located in an old scout hall. I had been in the boy scouts. I wanted to use a pole as a totem, a telegraph pole which referred to an idea of communication. The performance was a fairly ritualised akshun. Various elements were nailed to the pole: human hair, molasses. Stencilled on the floor in talcum powder, around the outside of the circle, are the words "earth hearth heart earth heart earth" The same letters but three

different words. Yellow pigment denoted bile. Vegetable oils were on my body and feathers on my arms. I wore a white shirt emblematic of a male presence. The soundtrack to the performance was by a Chicano poet, Jimmy Santiago Baca, texts relating to the nature of his addictions and of waste in his own community. The constant refrain that I sampled was "I am your enemy" – because of his poetry Baca had become a cultural hero. He was being assimilated into the academic world but remained resistant to that. He felt that people still didn't understand where he was coming from if they thought that he was one of them. There were links with my own questioning of myself as an artist, of how one could become separated from one's community or nourishment through, say, monetary or cultural kudos.

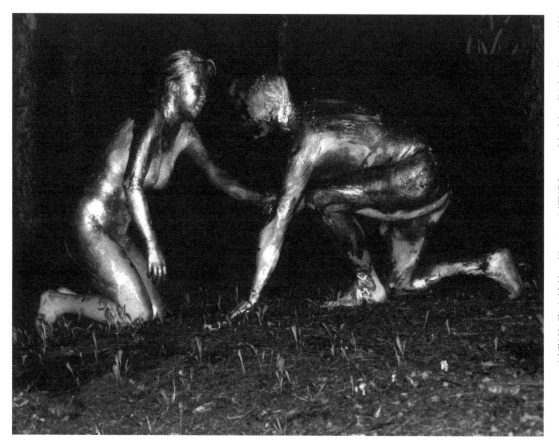

A I Shi Ma Shu (with Maya Wagatsuma), NIPAF Summer School, Izna Heights, Nagano, 1998

I was invited to take part in an Asian performance art series in Japan in the summer of 1998. Organised by Seiji Shimoda, the emphasis was on performance as pedagogy; the support of an emerging Asian network of performance art being furthered by the participation of established artists from Europe, such as myself and Zbigniev Warpechowski from Poland. The performance in Nagoya was titled *Heart Like a Wheel*, a reference to the song. I used a new bicycle wheel and tried to break it. There was a lot of hammering and smashing. The broken wheel became a mandala or hoop, it was treated – with oils, after-shaves and yellow pigment – and a cheap white shirt was hung from it. I incorporated Japanese pornographic magazines – which for the most part featured adolescent or nubile girls, usually wearing white underwear or white socks-and at certain points in this performance I rolled these magazines up and inserted them into my mouth, pushing them down my throat as a suffocating tool (an akshun repeated in Tokyo). I constantly pushed backward and forwards to the point of collapse, I was gagging violently. These soft images had become a hard phallus. Pornography was a devaluation but there was also the capacity to rise above this. At the end of the performance I had a little bowl of rice with a photograph in it which I burned, denoting the end of a

Killing Time, Streetworks, Glasgow, 1998

recent relationship. The Tokyo version was titled *You Only Live Twice*, which obviously alluded to aspects of my personal life but also referenced the Nancy Sinatra theme song from the James Bond film. It was played in the background during the performance. As a kid my first associations of Japan came from that movie.

I also worked with Maya Wagatsuma, a student at the NIPAF Summer School. The participants were living in chalets in a beautiful woodland area. Maya and I decided that we would both be naked and cover our bodies with pigment. We talked about love in relation to male/female and Japanese/ Eastern/Western culture, within the natural environment. We placed signs in Japanese and English on various trees and moved from

tree to tree, chanting "I love you" in our respective languages.

When I arrived back from Japan I received another Channel Four commission, for a show that was being televised nationally on a Friday evening. I was in a busy London street giving away free bananas, a funny form of food for obvious reasons. I enjoyed talking over the production in advance, and any problems that I might have foreseen didn't materialise. The production crew got into the idea of a guerilla akshun, of being on the street and not having permission. They liked that. On the few occasions that I have worked with camera crews they tend to really enjoy it because it's different from what they normally do. There were a load of winos grabbing bunch after bunch of bananas. They just saw lots of free stuff being given away, and I remember one of them came up afterwards asking if he could have some of the other props. There was a panic once they realised it was free.

Killing Time was part of Streetworks, a series of performances by artists around the streets of Glasgow. I had a placard with "Killing Time" on it in big letters. I covered different locations, starting out at the central train station. I was there for quite some time, standing in front of the main information notice board. That was quite nice, because of course there was, as always, a large crowd of people facing the notice board; I was in front of them looking back. There was one woman who was quite concerned that I was all right, asking if I had a home to go to. Was I OK for money? She was concerned about my welfare, I think that she thought it was some kind of protest against homelessness. I told her that I was actually just killing time.

Substance (Living In Two Worlds), Ex-Teresa, Mexico City, 1998

Eventually the cops came and escorted me from the premises. I had quite a long debate with them about the reasons why they wanted me to leave. They had had a call from the office from the Rail Track Manager who also thought that this was some kind of protest, this time against the bad running of the trains, which was quite nice really.

It was a simple akshun, any discourse dependent on the location, what establishment or shop I was standing in front of. I spontaneously interacted with whatever was going on in the street. There was a keyboard player with a battery operated amp, people playing music, so I started dancing in front of them. I would appear normal except I was holding this sign and asking people how they were. There were two Glaswegian tourist guides in uniforms, and I asked them about tourist attractions in Glasgow. It was obvious

that they didn't want to look at the sign, they were just ignoring it.

In 1998 I was invited to Ex Teresa, a deconsecrated church in the historical section in the centre of Mexico City. I wanted to erect a totem in the courtyard, so again used an old telegraph pole, this time as a reference to popular images of Mexico derived from old western movies or spaghetti westerns. Within the culture of Mexico it was also something of a crucifixion icon. There was a beautiful moment when this thing arrived, being brought through the main street by workmen. Kids were running behind and it was like a street celebration.

The akshun lasted fifty minutes. I began climbing up from the base of the pole and coming down, hammering notices and objects to it each time. I had visited a Mexican market with lots of stalls that sold shamanic trinkets and herbs used in local rituals. I bought a number of these and hung them from the top of the pole, used as cleansing elements. I wanted to be sure I was using the right mixtures of herbs for the cleansing, so I worked closely with a translator during the preparation.

The pole wasn't particularly well embedded in the earth and had to be held in place with guidelines at the top, which weren't that secure either. Climbing the telegraph pole which was quite dangerous, it was moving around a lot. Considering the high altitude of Mexico City the akshun was difficult; I had only been there a day before, so hadn't yet acclimatised. At certain points I didn't think I would be able to carry it through. My intention was to make a visceral connection with the subject of love. Spiritual love, the addictive quality of love, being

crucified by love. The pole, as a totem, became a reliquary, an embodiment of the real and the imaginary between life and death. At the climax I set the detritus aligned around the base of the pole on fire, still climbing up and down as flames began to spread up and consume the pole, until it became impossible to ascend any more. I circled the pole, ringing a bell. The audience, numbering several hundred people, had been quiet up to this point, but then erupted into cheering. The title *Living Between Two Worlds (Substance)* referred not only to internal and external worlds, but also the act of living between dominant and repressed culture. We move between many worlds. For instance, in terms of the global advances in technological communication, if e-mail seemingly brings us together how is it that we can't say hello to our next door neighbour?

The telegraph pole originally came from a tree trunk. The tree that I began to incorporate into performances after this point was inverted, hung upside down. I also cleansed it of its skin, stripped away the bark to expose the white interior underneath.

In *Nature Is Perverse*, in Stockholm, I hung a large tree upside down on a platform in the Moderna Museet. The backdrop to the performance was two large video projections of airports from around the world. I had spent a great deal of time over the last few years travelling, experiencing one airport as being pretty much the same as another. You don't necessarily know where you are, except that you are in transit. The tree's inversion was symbolic of this nomadic existence: the world turned on it's head, where nothing was the right way round. I systematically attacked the tree with a chainsaw, picked a fight with

it, alternately attempted to climb up but always fell off, slipped down the oils and talcum powder that I had anointed it with. The noise of these akshuns was masked out by a pre-recorded tape of jet planes played painfully loud through a large PA, causing the building to vibrate.

The next work, *The Envoy*, approached the condition of transit and inversion in a different way. Presented in Berne in Switzerland, the akshun was delineated over a central main space and a small ante-room. In the former space I hung a large tree upside down, in the latter I laid a large sheet of wood on the floor, with the mural 1961 painted in molasses. 1961 was a year in my life when my mother had taken my brother and I to visit our grandparents in Paris, and my father couldn't afford to go too. And here was his son travelling the world as an artist. I read this anecdote out as an introductory text, called Substance (I had read a similar version in Spanish for the earlier piece at Ex Teresa). I smudged the space, contorted my body, twisted around corners, inverted my body against the walls, attempting to dissolve myself into the fabric of the environment and the akshun. These movements would erupt and then slow down.

In the second part, I propelled myself into the main space, where a number of ritual elements – oils, talc, feathers – were laid out under the tree. Rather than attacking the tree, as I had done in Stockholm, I carefully stripped and treated it over a number of hours, using a small penknife. The activity was reverential, resulting in a stripped skeleton. I then hung a sign on the tree that simply stated "I Love You". This was still in 1998, my year of love.

The Envoy. Stadtgalerie. Bern. 1998

BLACK WINGS AND SOLDIERS' THINGS

I made *Learning to Fly* at Cardiff Art In Time, in February 1999, as an extension of my previous uses of the tree, but concerned with an evocation of cinematic imagery. I was trying to find a space that could help create a sense of the poetics of cinema, specifically the ambience of an Andrei Tarkovsky movie, those long static shots of human beings isolated within bleak environments in movies such as *Stalker*. I sourced a space with a concrete floor and bare brick walls, the best touch being a drainage channel running down the centre of the floor. When the audience entered I had taken the drainage cover off, and turned on a hot and a cold tap. The water rushed into the channel, filling the space with steam.

I had set a small birch tree in the channel, which the akshun hinged around. This young tree was chopped down, then stripped and beaten. The majority of my akshuns at this time were typified by my increasing concern with a loss of innocence. I had recently read about the death in Belfast in July 1998 of three children killed in a fire bomb because some idiot had thrown a petrol bomb through their window in a sectarian act, for no apparent reason other than they were Catholic. By all accounts the family had had no problems with other Protestants in the area. I had pinned an image of the three children onto the sapling, juxtaposed with toothbrushes, and military identity tags with "Learning to Fly" written on. Both the tree

and I were anointed with oils in an attempt to become one, and feathers were attached to my arms. What was our identity? Was there the possibility of learning to fly, to have the hope that we could learn from these lessons and overcome tragedy?

The trace elements of the children implied a formulation of new energy, evolutionary yet traumatic. There isn't necessarily an implied success in achieving flight, yet the possibility is revealed over and over within the moment of doing. For instance, in *O To Be In England*, another piece at this time, I incorporated a text at the end of the performance which was from an interview with a Loyalist prisoner. He had spent a long period in Long Kesh and he talked about seeing himself as a Protestant victim of the Troubles in Northern Ireland. He had shot a person as a teenager, and felt that he could never go back or become a whole person again. In a suicide note he had talked of hope that future generations would learn from our mistakes. This guy, Billy, committed suicide, and even though he had evinced this sense of hope, the end of the note stated "I am tired now, it is time to put this to an end". I had a sense of him offering himself as part of a cycle of rejuvenation and understanding. After reading this note I played "All the Young Dudes" by Mott the Hoople, an important song in my teenage years. The first line of the song is "Billy rapped all night about his suicide" and I broke down at that moment in the performance because of the weight of that

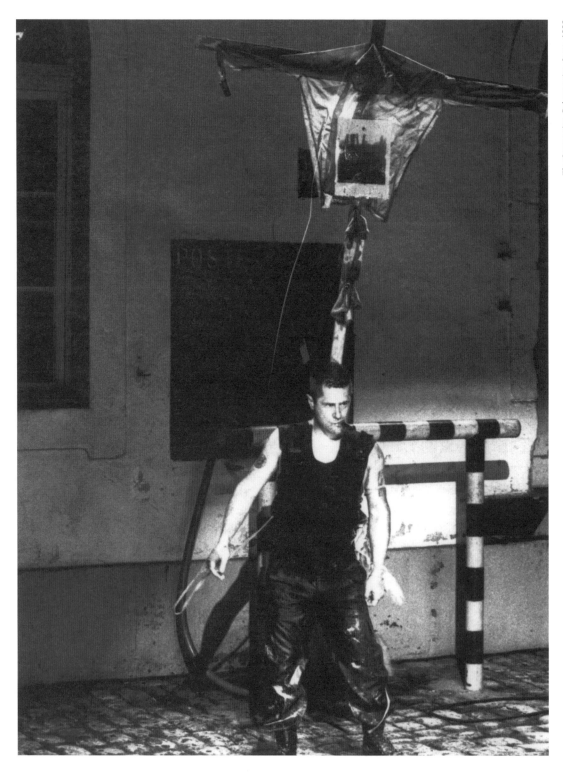

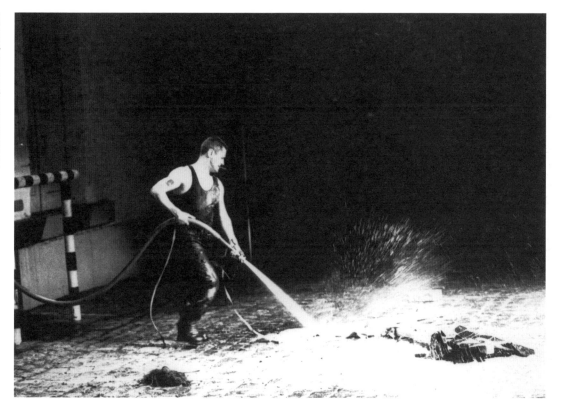

The Occupation, Polysoneries, Lyon, 1999

meaning. The piece was presented in a Village Hall in Dartington, the kind of place you associate with the English mythology of tea parties and garden parties.

Occupation in Lyon, was presented in an old covered market with a large glass roof, a cobbled area not unlike a town square. Any sound echoed forcibly around the space, so I bombarded it with the sound of jet planes flying back and forth. Three clocks denoted the time in London, New York and Tokyo. In the beginning I had stencilled the phrase "You Have Colonised Our Consciousness" in large red pigment and blood letters. Throughout the duration of the akshun, this protest gradually became eradicated as I enacted a series of highly aggressive and confrontational movements: a repetitive act of putting a gun to my head, attempting suicide, physically wrestling with myself. I had a crucifix strapped to my back, covered in a white shirt steeped in blood, growing out above my head. I was smoking a cigar, wearing a black combat uniform, striking macho poses; in my mind I had the image of a comic book hero, a Sergeant Fury. The absurdity of the persona vied with the brutality of the akshun. I used a fire hose to cleanse the whole area, in a correlation with crowd control and dispersal – a high-powered jet of water that washed the detritus and the sentiments of the text away. I wanted to create a sense of a world in a flux of constant occupation, colonised by the forces of capitalism, the big boys.

I expanded on the concept of "the world's policeman" in *Witness*, shown at PS1 in New

Where The Grass Is Greener, Amorph!, Box Forum Gallery, Helsinki, 1999

York as part of a group exhibition of Irish artists living in London. I was asked to make a performance for the grand opening. There was a large crowd of about two thousand people. I had decided to use the steps of the entrance to the exhibition space, which dominated a large courtyard, placing myself at the threshold of the museum (the last time I was in New York I had been working the streets on Broadway so this time I had moved closer, but was still not being allowed in the doors). At the top of the steps was a large totemic sculpture by Marina Abramovic with an energy crystal on top. Marina originally came from the Balkans, and the exhibition was being held at the time when NATO was intervening in that area. I had also been corresponding with an artist called Tanya Ostajic, who was living in Belgrade, about the

problems of that intervention. As I was in the United States it seemed appropriate to query certain aspects of this.

Local DJs were playing loud music, which we thought would stop for the period of the performance, but I decided to let the music play; I liked the resonance of having American music playing, and started working to the rhythm. I had in advance attached a funeral wreath, with the words "Pride" made up in red, white and blue flowers, to Marina's sculpture. Once the audience had gathered I built a cross, draping it with a white shirt and wig-like a scalp-covered in yellow pigment. This was strapped to my back, projecting above me like another body. I picked the wreath off of the sculpture and walked to the top of the steps, set it on fire and held it aloft to the crowd. I walked down the steps and

through the crowd, distributing postcards to the crowd made by Tanya, that had a picture of her hair cut into a target and the statement on the back "I want you to take responsibility for the bombing of Yugoslavia".

A lot of people understood what was taking place and found the references coherent and straight forward, but there were also many people who actually asked what was going on in the Balkans (an indication that they probably weren't that interested). After having experienced a high level of debate about the issue of intervention in Europe, it seemed to me that these people were ill-informed about both the nature of the conflict and its potential tragic outcome.

I introduced a new feature-a boat-that would recur over a number of akshuns, in Helsinki with *The Grass Is Greener*. A clear reference to migration, of moving to a new life. I worked directly onto a rowing boat, coating it in large quantities of molasses, caressing it and rubbing feathers over its hull. I had painted the word "Home" on the back wall, also in molasses. I used an akshun that first started to occur in this piece, wherein I held my belly; a feeling of holding your centre, for example in relation to formative experiences of childhood. Holding your strength and centring oneself but also feeling that something was growing inside. I simulated an injury on my belly, letting the centre be ripped out.

At a certain point I asked the audience to pull the boat from the gallery – the idea being to pull it across the main thoroughfare to the quayside in Helsinki Harbour, and to launch it into the harbour. The audience was highly charged by the ritual of the akshun, very eager, and got carried away, pulling the boat almost half a mile away up the road. Many

hands were involved in launching the boat, which drifted out to sea. My intention was to examine the concept of letting go, of making a transition in spite of the fear. The Vietnamese boat people, for instance, had had to have that faith: to go and be accepted somewhere they didn't know. There was a photograph in the boat of a street child from Columbia, a young girl about maybe six or seven years old, holding a broken comb. Perhaps her only possession. The look on her face was one of anger tempered with a cold hard understanding of what her position was, her need for survival. That image was frightening to me, it haunted me.

On a separate, personal level I had still been doing building and construction work to support myself, and I wanted to make a correlation between my own working history and that of the local boat industry. At this point I had decided to take up a full-time teaching job at the Cardiff School of Art, making a transition of my own from one territory to another.

Three days later, in Turku in Finland, *Stranded* was a more direct and aggressive akshun, with direct references to the ongoing predicament and situation in the Balkans, driven by my sense of a personal and communal inadequacy to resolve things; a feeling of powerlessness about how our nations go about their business.

The soundtrack was simply the pulse of a CD player held on pause, a mechanical, direct and clinical sound that created a tension and rhythm; a rationale appropriate to the hard progressive akshuns undertaken within the performances. A long table was the central feature, covered with an immaculate white cloth. There were obvious parallels with an

operating theatre, but also a place of conference, of talking and negotiation. At a conference level, when dealing with gritty issues, one can imagine how impulses and desires have to be tempered by the protocols of negotiation: everything is real and nothing is real. Masks are worn and vulnerabilities disguised. I placed rows of white cups and plates, surrounded by silver cutlery, as a form of genteel accoutrement.

At the very start I negated protocol by kneeling on the table. The negotiation was already going wrong. The tableau was progressively disrupted: I immersed my head in a bucket of cow's blood, threw my head back splattering the cloth. I stood up and smashed the crockery with my feet, drawing it into the centre, wrapping it in the tablecloth and hoisting it like a body bag. An extended crucifix protruded from the back of my head, to which a funeral wreath was attached and eventually set on fire. On the wreath was a small body of texts, which the audience could only read if they came close enough. Article 10 number 1 of the international covenant on civil and political rights, and article 1 of the UN convention against torture, other cruel, inhuman or degrading treatments. *Resistance*, presented at a festival in Odense in Denmark, concluded this cycle, a consequence of the previous month's activities, but some of the elements and motifs have since been used again, derived from a continuing exploration of resistance.

SOMETHING IN THE AIR

Penance was designed for an event in October 1999 in a converted banquet hall in an old castle at Sandomiercz in Poland. Most of the townspeople came to see it: families with children, mothers with babies in prams. It was a real communal event. I wanted to make something direct and sparse. I converted a tree into a spear or javelin by stripping and whittling it down, then held it aloft as some form of arrow or weapon. Penance is a central issue within many traditions, both spiritual traditions and judicial. Within such simple askshuns there was a feeling of connectivity; working through the attendant political motivations of Northern Ireland has parallels with similar processes in Poland and Eastern Europe. There are connected traditions.

Promises of Paradise, was commissioned just prior to Christmas 1999 for Art Trail in Cork, Ireland. I had access to the space well in advance, and had the time to build an ambitious installation: a large antique rocking horse, a tall Christmas tree that touched the roof of the space, a building reduced to the scale of a child's play house-but detailed and 'realistic', partially destroyed and weather-blown, half the scaled-down tiles missing from the roof. I wanted to play with these elements, to induce a child's perspective on the whole installation. Things were contorted, reality was shifting, it was a dysfunctional Christmas.

I was dressed in my usual black combat gear, which quickly became whited out as I threw huge quantities of talcum power around

the set. A sweet talcum mist pervaded the installation and the audience, partly magical like the cliched image of snow purifying things, yet also resonant of the essentially synthetic nature of modern Christmas. I wrestled and stripped the tree, scattering the decorations. I wore red contact lenses that made my eyes look bloodshot, 'flying' over the house, embodying the duality of shadowy figures used to scare and enchant children at bedtime stories-a guardian or a bogeyman?

The house was a symbol of the centre of a community. I climbed onto the roof, looking down on the community, and nailed an archaic wooden cross, which had little bird's wings attached, on the apex of the roof. I played music at the end: "Something in the Air", a song from the late 60's about revolution being in the air that I associated with the real start of the Troubles. I remember we used to sing it running through the streets of Belfast. On the back wall of the space I wrote "sweep the garden any size", a Zen saying. We must always sweep the garden, take responsibility. The garden can be any size from the mind out; the environment, the earth, the universe.

The Elements, at the Newling Gallery in Cornwall, involved the use of a boat again; but this work came out of a year of discussions with indigenous people, and was intended as a metaphor for the decimation of the fishing industry, and the subsequent effects on that community. When the fishermen were laid off and given compensation they often didn't know what to do, so they were just drinking, drinking the money away. At the same time surf culture was emerging in Cornwall, with a consequent introduction of drugs such as ecstacy and acid to the area. There was a real conflation of cultures, of hedonism and desperation, of youth and decrepitude. A lot of ex-fishing guys were drinking and taking acid. What do you do when the bottom falls out of your world and you have no real way of dealing with it? What if you have no other skills to rescue you?

As in the Helsinki work the manipulation of the boat involved a series of traumatic and emotional movements, of nurturing a sense of loss embodied by the shell of the boat, tarring and feathering it, marking it as an outcast. The word "Jonah" – outsider – was painted in molasses on the back wall. I particularly wanted a female voice to act as a counterpoint to the male activity; as so often when male-dominated industries collapse it is the women who pick up the pieces, who are the 'caretakers'. Siri Austin, an Oslo-based vocal artist, provided me with a vocal lament that combined Celtic, Gaelic and Cornish intonations. I eventually dragged the boat from the gallery, washed and cleaned the feathers and molasses from it, and hammered a small wooden cloth with bird wings onto its front. It became a grave. I held a small sample jar containing a blotter of lysergic acid up in the moonlight. That was the end of the performance.

The next part of the Elements series – *Innocence* – took place in Seattle, at the beginning of March 2000. I had been interested in working with younger practitioners, especially in the United States. A group of young artists from Seattle that I had previously met in Mexico provided myself and a number of European practitioners with an interesting intersection of experience. Events were produced on a low budget but they were well organised and attended.

We built a large free-standing plaster board dry wall across the centre of a large warehouse, set diagonally to allow the audience to move around it, or follow the action from one side to the other and through the wall. In the middle there was a door with a peephole. I stood static for a considerable length of time, just looking through this hole in the door; to the audience it just looked like I was stood against the wall. I wore red contact lenses. If the viewer walked around the other side of the wall they would see this red eye looking through the door at them.

I was staring through the peephole to the other side, watching a TV monitor playing an episode of "Watch with Mother", an old popular British children's show in black and white. The main akshun revolved around smashing my way through a section of the wall with an axe, running through the hole, then turning left and repeating the process. I was moving in a tightening circle that intersected at sections of the wall. I washed large quantities of used children's clothing in buckets of black pigment, which were carried continuously through the holes in the wall. I attached a wooden cross and wings and two photographs-one of the Colombian girl that I had used previously, the other side the famous surveillance camera shot of two boys taking away James Bulger, the little boy murdered by two other children who were not much older – to the door, and wrote "we have cultivated innocence as a style and it has stood in our way of being accountable". I set the threshold on fire and then kicked the locked door open. The flames spread to the remaining wall as I left the space. There was no backing sound except the sound coming from the monitor. Cultivating innocence as a style-which is something this society does at many different levels, not least in its construction of a sanitised mind set for children – is a form of dishonesty. We need to be more responsible, to take more care to eradicate ignorance and become acutely aware of our own agenda in particular circumstances.

In May 2000 I was asked to produce something for the Cathedral Quarter festival in Belfast. I decided to make a street piece; to find a way of really coming home, or making peace with the past-especially in light of recent developments in the Peace Process in Northern Ireland. The Duke of York pub is in the middle of the Cathedral Quarter, in the city centre. My father drank in there, hanging out with reporters from the News Letter Newspaper. I spent a lot of my childhood there. Gerry Adams was a barman. I decided I wanted to revisit this experience in the light of an early political awakening I had at the age of ten, when I had been taken over to the newspaper office. A photo was coming over the wire of the two black athletes, Smith and Carlos, who had held their fists in a black power salute during the playing of the "Star Spangled Banner" after receiving their Olympic medals. This was at the 1968 Olympics, during the time of the emergence of a Civil Rights movement in Northern Ireland, just before the Troubles started in Ulster. I remember being exhilarated by this image; of how a public action could make a point, could possibly change things.

The akshun took the form of me crawling on my hands and knees from my childhood home in Donegal Pass to the Duke of York bar. I wore framed photos of Smith and Carlos on my front, and a photo of my father

Conviction, Cathedral Quarter Festival, Belfast, 2000

and two friends taken in the 50s on my back. My head was covered in feathers and molasses and I was exhausted; people would get a bit freaked out, think that I had suffered some sort of punishment. On the other hand there had been a lot of publicity about it. During my journey people were talking to me, encouraging me, giving me tissues to clean my face, as the stuff was dripping in my eyes and I couldn't see where I was going. The photos were hung permanently in the Duke of York. This akshun resolved, for me, a lot of issues that I've had with my home town, country and identity. It was called *Conviction*, and felt resonant, poignant and mature. I couldn't have got much closer to the very

foundation and fabric of Belfast than that, literally dragging myself over its streets.

I believe that we live within a universe that offers us a choice: that there is the capacity within human beings to demonstrate both good and evil. Perhaps one could perceive evil as being a form of insanity. We have to give recognition to how those evils come about. Many of them seem to be based on issues of individual and group narcissism. Studies on the nature of evil by popular psychologists project a discourse relating to a concept of redemption. It depends how far you want to recognise certain realities of a capitalist, consumerist society seemingly devoid of spiritual content.

Ultimately, of course, responsibility is conferred upon us all; and if one is not being responsible one is not paying attention. My works are about paying attention, about asking questions and trying in some small measure to address imbalances in this struggle. We all have within ourselves these opposites. If you have respect for yourself by extension you will respect all others and all life.

If you take care of this moment, you take care of all time.

This text has been edited from an extensive Q&A between André Stitt and Roddy Hunter.
Easter 2000

ANDRÉ STITT

born Belfast, N. Ireland, 2 March 1958

Duck Patrol [w/Tara Babel], Central London
Sensory Deprivation, Exiles Studio, London
Presentation, Leeds Leisurewear, Leeds Polytechnic
The Larynx, Basement Group, Newcastle upon Tyne
Hey Brujo [w/Tara Babel], Epping Forrest, Essex
Dogs In Heat, London Film Co-op
Dogz/Duck Patrol [w/Tara Babel], Moonlight Club, London
The Hebephrenic, Finsbury Park Carnival, London
The Hebephrenic, Exiles Studio, London
Food Fer Thought [w/Tara Babel], Mega Event, Chats Palace, London
Hebe Fire In Head [w/Tara Babel], Exiles Studio, London

1982
Food Fer Thought/The Hebephrenic [w/Tara Babel], NOW Festival, Crescent Centre, Belfast
Food Fer Thought/The Hebephrenic [w/Tara Babel], Orchard Gallery, Londonderry
V.A.L.I.S. Exiles Studio, London
Hebe Garage Akshuns, various locations, London
Casting Runes, Exiles Studio, London
The Shadow [Metis-Anima], Exiles Studio, London
Little Religions, Middlesex Polytechnic, London
Blood Brother/Blood Sister [w/Tara Babel], Exiles Studio, London
Six Degree Maximum Headroom [w/Eden Diebel, BMUS & Tara Babel] Waterloo Gallery, London
Opium Eater[Dragon], Exiles Studio, London
The Shadow [Ideos-Anima], Exiles Studio, London
Head Hunter, New Forest, Hampshire, England
Psychometric Recordings, New Forest
Terra Rituals, Exiles Studio, London
Fax & Fikshunz [Fact or Fiction?], Middlesex Polytechnic, London
Terra Incognito, 3rd National Review of Live Art, Nottingham
Terra Inc. [w/Tara Babel], Zen Abattoir Event, Idiot Ballroom, London
Terra Inc. [w/Tara Babel], Zen Abattoir Event, London Musicians Collective

1983
Reportage, Visa Video Event, New Regent Club, Brighton
Listen To Me, Expanded Media Show, Sheffield
Dirt Agent Benefactor, The Slammer, London
Quarter Blues Blues, Whittington Hospital, London

Terra Inc. [w/Tara Babel], Aspex Gallery, Portsmouth
Conspiracy [kon-spir-a-si], Live Irish Art, Franklin Furnace, New York
Brooklyn Bridge Akshuns, New York
Concrete ['os] [w/Tara Babel], Belluard Festival, Fribourg, Switzerland
March Fuckers March, Conciel General, Geneva, Switzerland
The Tourist, West End, London
Tourism [Remote Viewing], A Morality Event, Ealing College, London
Kincora [Violations By Gods Bankers] [w/Paul Bowen], Air Gallery, London

1984
Kincora [Violations By Gods Bankers] [w/Paul Bowen], London Film Co-op
3rd Degree Murder [w/Tara Babel], Drayton Park Dome, London
Tourism [w/Tara Babel], Perfo-2 Festival, Rotterdam
Apt-8, Data Cell & Canada House, London
Proceedings, Air Gallery, London
Kincora [Violations By Gods Bankers] [w/Paul Bowen], Arts Council Gallery, Belfast
Love Crimes, Irish Exhibition of Living Art, Project Centre, Dublin
Fragment-4, Exiles Studio, London
Fragment-4 [w/Paul Mackay & Sean Fitzgerald], The Fridge, London
The Geek Underground [w/Paul Mackay & Daniel Wihler], Covent Garden & London Underground
The Geek [w/Paul Mackay & Daniel Wihler], the Clinker Club, London
Tourizm #2 [w/Tara Babel], Zap Club, Brighton

1985
Short People, Central London
Peep Show, Soho, London
Hot Dog... You Bet! [w/Paul Mackay & Christine Pinturault], Exiles Studio, London
Hot Dog [w/Paul Mackay, Christine Pinturault & Fiona Pang & others], NE London Polytechnic
Hot Dog [w/Paul Mackay, Christine Pinturault, Fiona Pang & others], London School of Economics
Satellites, Exiles Studio, London
Wino Man, various locations, London
Paradise Passage, When the Shit Hits the Fan, Whitechapel, London
Love Crimes [pts 8-11], London Film Co-op Summer Show

Glamour & The Geek [w/Tara Babel & Christine Pinturault], October Gallery, London

Financial Times, London Underground

1986 *Night Thoughts*, Pitt St. Studios, Sheffield

Tory Cowboys, Wimbledon Civic Hall, London

Fugue State Akshuns, Exiles Studio, London

S.O.B. Peeping, Contemporary Arts Fair, London

Interiors [We Take The B Out Of Banal] [w/Tara Babel], Belluard Festival, Fribourg, Switzerland

Disco Daze, Hollywood East, Bern, Switzerland

Touch Me [I Want Your Body], Streets Alive, Sheffield

Fugue States [1-4], Perfo-4 Festival, Rotterdam

Fugue States [5-8], Live Art Now, Zap Club, Brighton

Fugue States [9-12], 5th Street Theatre, Austin, Texas

Houston Is Hot Tonite, The Orange Show Foundation, Houston, Texas

Fugue States [13-16], Blue Star Gallery, San Antonio, Texas

Finger Lickin' Good, Kentucky Fried Chicken, various locations, Texas

Geek Feast, Santa Barbara Contemporary Arts Forum, California

1987 *No Pope Here On The Freeway [AKA Manhunt West]*, at The Edge, Air Gallery, London

Mysteries #1, Milton Keynes Exhibition Gallery, Milton Keynes, England

Night Thoughts, Laing Art Gallery, Newcastle upon Tyne, England

Mysteries #2, Cambridge Darkroom, Cambridge, England

Night Thoughts, Theatre In The Mill, Bradford, England

Night Thoughts, Cornerhouse Gallery, Manchester, England

Mysteries #3, Darlington Art Gallery, Darlington, England

Aquarium, Aniki Bobo, Alternativa-4, Oporto, Portugal

Sharks Teeth, Town Centre, Aveiro, Portugal

Changing Strangers, Jardim da Delicias, Galeria Maria Isabel, Aveiro, Portugal

1988 *Ask Mother* [w/Shaun Caton], Exiles Studio, London

The Last Supper & The Dry Dive, Intervention-4, Café de la Danse, Paris

Covert Activities [AKA Red Herrings], International Conference on Sculpture, Project Arts Centre, Dublin

Covert Akshuns, Northborough St. Warehouse, London

1989 *No Pope Here on The Freeway [AKA Rexall Ranger]* Commerce St. Artists' Warehouse, Houston, Texas

Covert Activities [Hardcore Akshuns/Live Mix] Mexic-Arte, Austin, Texas

Dallas [The Quest For Captain Sad], Club DaDa, Dallas, Texas

Boke Factory [w/Tara Babel & Shaun Caton], Zero-One Gallery, Los Angeles, California

Covert Activities [Hardcore Akshuns/Live Mix] Highways, Santa Monica, California

Blind Mans Bus, Artists' Television Access, San Francisco, California

Geek Love, Club X, London, Channel 4 TV, UK

Network [w/Jon Held Jnr.], Exiles Studio, London

1990 *April Fool, Irish Spring, Ulster Fries*, De Media, Eeklo, Belgium

Change Is Not a Motel [AKA Baton Rounds] Ideophrenia, Pitt Gallery, Vancouver BC, Canada

Baton Rounds & Butcher Boys, Ward-Nasse Gallery, New York

1991 *Cairns [AKA The Past Is Entombed In The Present]*, The Last Weekend, Alston, Cumbria, England

Tex-Mex-Hex, El Dia De Los Muertos, studio 52, London

Romper Room, Eye To Hand, The Heritage Centre, East End, London

Romper Room [AKA Did My Friends Have Fun At Play], Exiles Studio, London

Collages 1984-1991, Exiles Studio, London

1992 *Tit Fer Tat/Kill The Kin*, Sheffield Media Show, Film Co-op, Sheffield

Hot Dog, Exploding Cinema, London

Local Gods, Shreikback Video, Leyton Crescent, London

1993 *Poop Scoop*, Woodworks, Spring Gardens, Vauxhall, London

Geek Shop, Woodworks, Vauxhall Underground Station, London

Free Geek, Exploding Cinema, London

Gridlock [AKA Slackers Picnic], Catal Huyak, Houston, Texas

Gridlock [AKA Gang Of One], Club DaDa, Dallas, Texas

Gridlock [AKA I Will Work For Nothing], Electric Lounge, Austin, Texas

1994 *The Geek [Rest in Peace]*, Winterschool, Glasgow

1995
Gridlock [AKA Vigilante Man], Violence of the Imagination, Zap Club, Brighton
Gridlock [AKA Who Wants to Buy Me], 3rd International Performance Festival, Rotterdam
Fort Port Akshun, Schiedam, Holland
Crow, Cardiff Art In Time, Chapter Arts Centre, Cardiff
Crow [Yellow Sky, Yellow Rain], Galerie QQ, Krakow, Poland
Scrubbing Skin, Nowa Huta, Poland
Floating Skin, Birkenau, Poland

1996
Second Skin, Cardiff Art in Time
Second Skin [Behind The Mask], NIPAF, Japan Foundation Forum, Tokyo
Second Skin [Other Stories], NIPAF, Workers Prefectural Hall, Nagano
Threshold, Circa Office At Night, Belfast
Second Skin [Inquisition], Project Arts Centre, Dublin
Speak To Me Of My True Names, FIX, Catalyst Arts, Belfast
The Secret Place, Castle of Imagination, Bytow, Poland
Shelter, Smolinski National Park, Baltic Region, Poland
Slip Inside This House, Baltic Arts Centre, Ustka, Poland
Europe Endless, AnnArt 7, Lake St. Annes, Transylvania, Romania
Stalker/Deadhead, Smolinski National Park, Baltic, Poland
Skin/Exiles/Nomads, North London University
Second Skin [Final Solution], ASA Performance Konferenz, Köln, Germany
Ceasefire [Make Sure You Have Bread On The Table] Rencontre Internationale, Le Lieu, Quebec
Ceasefire [The Ties That Bind Us], Cinecycle, Toronto

1997
Eat Your Words, Exiles Studio, London
God Is Sexy, Broadway, New York
Heal Yourself, Wig Club, Baltimore
East [Workhorse], Wong Spot, San Antonio, Texas
Burnt Ta Fuck, Amorph!, Tampere International Theatre Festival, Tampere, Finland
Toxic, Inner Arts, Fire Station Studios, Dublin
Harvest [24 hour akshun], [w/Kate Ellis & Catherine Waller], Fort Sztuki, Krakow, Poland
Harvest [For The Children], [w/Kate Ellis & Catherine Waller] Transart, Nova Zamky, Slovakia
Harvest [Sweep The Garden, Any Size], [Kate Ellis & Catherine Waller] Artpool P-60 Gallery, Budapest
At Climax, Rootless, HTBA, Ferrans Gallery Hull, England
Communion, UKS, Oslo, Norway
Respect, UNESCO Art Hansa, Köln, Germany
Autumn Perennial, Maschinhaus Zech Carl, Essen, Germany
Winter Light, Kunstraum, Dusseldorf, Germany
Winter Light, Kunstfabrik Tor1, Köln, Germany
Sweet Surrender, Kunstlerhaus, Dortmund, Germany

1998
I Love You, Sub Versions, Nottingham
The Woman Who Fell To Earth, The Medium Is Not The Message, Red Gallery, Hull
Substance [AKA The Enemy], Intermedia, Cork, Ireland
Heart Like A Wheel, NIPAF Asian Performance Series, Nagoya, Japan
You Only Live Twice, Kid Ailack Art Hall, Tokyo
A I Shi Ma Shu [w/Maya Wagatsuma], NIPAF Summer School, Izna Heights, Nagano
To Say Goodbye, Neon Hall, Nagano
Perimeter, Heathrow Airport, London
Free Food, Tooting Broadway, London, Channel 4 TV, UK
Killing Time, Streetworks, Glasgow
Substance [Living In Two Worlds], Ex-Teresa, Mexico City
Nature Is Perverse [The Envoy], New Modern Museum, Stockholm, Sweden
The Envoy, Stadtgalerie, Bern, Switzerland

1999
Learning To Fly, CAT Show, Cardiff
O, To Be In England, A Year of Sundays, Dartington Village Hall, Devon, England
The Occupation, Polysoneries, Lyon, France
The Colony, Infusion, Limerick, Ireland
Once Bitten, Twice Shy, InterAction, London
Witness, PS1 Contemporary Art Museum, New York
Where The Grass Is Greener, Amorph!, Box Forum Gallery, Helsinki
Stranded, Turku Academy of Art, Turku, Finland
Resistance, PFO, Odense, Denmark
Penance, Sandomeiz Castle Museum, Sandomierz, Poland
Promises OF Paradise, Art Trail, Guy's Building, Cork
The Elements, Art Surgery, Newlyn Gallery, Cornwall
Enlightenment, Art Surgery, Newlyn Gallery, Cornwall

2000	*Innocence, Full Nelson III*, Powderkeg, Seattle, USA
	Conviction, Cathedral Quarter Festival, Belfast
	Detention, Interakcje 2000, Piotrow Trybunakski, Poland
	Convention, Dolnoslaski Festival Sztuki, Wroclaw, Poland
	Comfort, National Sculpture Factory, Cork
	Honour, British Performance Art Show, Köln, Germany
	Sacrifice, End of Milleneum, Bergen, Norway
	Dolphins, National Museum of Wales, Cardiff
2001	*Homework*, Le Lieu, Quebec, Canada
	Legends of the Evergreen Coast, Western Front, Vancover, Canada
	Evidence, Open Space, Victoria, BC, Canada
	Lemon Bloody Cola, Centre Cultural Recoletta, Buenos Aires, Argentina
	Missing, Museum of Contemporary Art, Santiago, Chile

EXHIBITIONS

SOLO
1985	*Snuff*, Lantaren/Venster Gallery, Rotterdam, Holland
1985	*Satellites*, Lamont Gallery, London
1990	*Mini Retro*, De Media, Eeklo, Belgium
1993	*Akshunartifax*, Arts Council Gallery, Belfast
1997	*Domestic Scenes*, BoBo's, London
1999	*Learning To Fly*, BoBo's, London [collaboration with Midori Mitamura]
2000	*Homework*, Howard Gardens Gallery, Cardiff
2001	*Homework*, Le Lieu, Centre en art Actuel, Quebec

GROUP
1978	*The Almost Free Art Show*, Arts Council Gallery, Belfast
1979	*Exhibition of Visual Arts*, Crawford Municipal Gallery, Cork, Ireland
1979	*Art Core Meltdown*, University of Sydney, Australia
1979	*Irish Exhibition of Living Art*, Bank of Ireland, Dublin
1980	*EVA*, Limerick, Ireland
1980	*New Works*, Act One Scene Two Gallery, Belfast
1980	*Eccentric Images*, Millenkin Gallery, Spartenburg, USA
1980	*The Badge Show*, Forte del Marmi Municpal Gallery, Italy
1981	*Exhibition of Drawing Signs*, Rysunku Gallery, Poznan, Poland

1982	*SADE*, Crawford Municipal Gallery, Cork, Ireland
1982	*Artz Attack*, Project Arts Centre, Dublin
1987	*Confrontations*, Projects UK touring exhibition
1988	*Air Mail*, Air Gallery, London
1988	*Flags Along The Liffey*, Dublin
1989	*Hardcore*, Mexic-Arte Museum, Austin, Texas
1990	*Fanzine As Object*, Karl Ernst Museum, Hague, Belgium [& touring]
1993	*Of Love*, Galerie Satellite, Paris
1994	*AART*, Irish Museum of Modern Art, Dublin
1994	*Paquet Cadeaux*, Galerie Satellite
1995	*Expedition in the Performance World*, Artpool, Budapest
1997	*Doing In It's Own Right*, Serpentine Gallery, London
1997	*Bull*, The Albany, London
1998	*Bull*, the Tramway, Glasgow
1998	*FIX*, Old Museum Gallery, Belfast
1998	*Letter Word Sentence*, Fort Sztuki, Krakow, Poland
1998	*Streetworks*, Streetlevel Gallery, Glasgow
1999	*0044*, PS1 Contemporary Art Museum, New York
	0044, Albright Knox Museum, Buffalo, New York
	The Future In The Present, Franklin Furnace, New York
	Clean Slate, Wales Art International & The Artist's Project, Cardiff
2000	*0044*, Ormeau Baths Gallery, Belfast
	0044, Crawford Municipal Gallery, Cork

BIBLIOGRAPHY

1978	'Pouring Cold Water On Hot Art', *Belfast Telegraph*, Nov.
	'Burning Interest In Art', *Art Monthly*, Dec.
1979	'Art Vandal At Work', *In Dublin*, Dec.
1980	'Akshun Man', *Vox Magazine*, Dublin, June
1981	'Cabaret Futura', *The Guardian*, Jan., *Time Out*, London, March & April
	'Message From The Akshun Man', *Vox #8*, Dublin
	'Performance Art', *NME*, 19th Dec.
1981 –	From 1981 – 1987 *Performance* magazine [UK] published regular reviews, interviews and articles. Issues #: 12,16,17,18,20,21,22,23,28,30,32,36,37,47 [available at the Live Art Archive, Trent University, Nottingham, UK]
1983	*Contemporary Irish Art*, by Roderick Knowles, Wolfhound Press, Ireland

1984	'Kincora & Love Crimes', *Circa*, Summer
	'Bataille Line', *Time Out*, London 4-14 Oct.
	'Escape From Northern Ireland', *High Performance* #27
1985	Interview, *ND* #5, Austin Texas
	'When The Shit Hits The Fan', *i-D*, April/May
1986	'My Art Belongs To Dada', *Tatler*, March
	'Street Theatre Branded A Waste', *Sheffield Star*, 13th Aug.
	'Performance Artist Set For Gallery', *San Antonio Express News*, Texas, 12th Nov.
1987	'Texas Tour', *ND* #8, Austin, Texas
	Figures, Cambridge Darkroom, Cambridge [cat.]
	Confrontations, Projects UK [cat.]
	Alternativa-5, Galeria Roma e Pavia, Oporto, Portugal [cat.]
1988	'The Right Angel Boils at 90', *High Performance* #42
	'A Battle With Tradition', *High Performance* #44
	Intervention-4, Galerie Diagonale, Paris [cat.]
	International Conference On Sculpture, Live at Project, Trinity College & Project Centre, Dublin [cat.]
1989	'Why They Called It Hardcore', *Public News*, Houston, Texas, 31st May
	'Club DaDa', *Dallas Observer*, 15th June
	'Disparate Pockets, Forty Under Forty', *Art & Design* Vol.5 #3/4
	'Trixter Akshun Cycle', *High Performance* #48
	'Ask The Artist', Dallas Cable Access, 8th June
	'Cable Show Gets Viewer Complaints', *Austin-American Statesman* [circa Dec.]
1990	*Fanzine As Object*, Brussels Art Festival, Belgium [cat.]
1991	*The Last Weekend*, Alba #4, Scotland
	'My Dinner With André', *Lightworks*, USA
	'André Stitt Performance', *Metro Riquet* #8, Paris
	Live Art, by Robert Ayers & David Butler, AN Publications, UK
	Other Visions, Irish Experimental Film & Video, 6th Dublin Film Festival [cat.]
1992	'Sheffield Media Show', *Variant* #12
	Festival de Performance II, Public Art, Madrid [cat.]
	1992-94 Exploding Cinema, London [programme booklets]
1993	*Akshunartifax*, Arts Council of Northern Ireland [cat.]
	'Against The Tide', *The Guardian*, 9th Aug.
	'Exploding Cinema', *The Face*, Sept.

	'Woodwork', *Hybrid Magazine* #4
	'Shankill Butcher Shocker', *Sunday Life*, Northern Ireland, 18th Sept.
	'My Fear By UVF Artist', *Sunday World*, Ireland 19th Sept.
	'Row Over Sick Art Show', *Cork Examiner*, Ireland 20th Sept.
	'Edge To Centre', *Circa* #66
	The Trouble With Art, Double Band Films for BBC & RTE TV Ireland
1994	'Winterschool Glasgow', *Architectural Journal*, Feb.
	'Kunstpikhowel', *Rotterdam Circuit*, Holland, May
	'Working On The Bypass', *Circa* #69
	The Head Is The House, Gallery GaGa, Rotterdam [cat]
	Sensoria In Sensorium, Mangajin Books, Toronto
	Performance Art – Into The Nineties, ed. Nicola Hodges, A&D Publications, London
	Working On The Bypass, CD & Book, ND, Austin Texas
1995	'Performance BWA & Galerie QQ', *Gazeta Wyborcza*, Poland, 23rd Oct.
	'Grey Suit #9', *Video Magazine*, UK
	Rapid Eye, ed. Simon Dwyer, Creation Books, London
	Crow, Galerie QQ, Krakow, Poland [cat.]
	Words & Pictures #4, London [box multiple]
	Tiltott 1980 – 1990 audio document, ND, Austin, Texas
	Video Expedition In The Performance World, Artpool, Budapest [cat.]
1996	'Akshun Man', *Irish Times*, 28th March
	'Front Row Seems A Dangerous Place', *Irish Times*, 2nd April
	'Irish Days', *Gazeta Morska*, Poland, 25th July
	'Transylvanian Performances', *Gazeta Wyborcza*, Poland, 24th Sept.
	'Come Back To Life', *Performance Research* #3
	'Performances Quebec/Toronto', *New Primitive Art* #12, Korea
	'NIPAF & FIX', *Inter* #66, Quebec
	3rd Nippon Performance Art Festival, Japan [cat.]
	Locus+ 1993-1993,Locus+, Newcastle upon Tyne
1997	'Recontre Performance at Cinecycle', *FUSE* vol.20 #3, Toronto
	'Recontre Internationale d'art performance Quebec', *Inter* #67, Quebec
	'Broad and Narrow, Inner Art', *Irish Times*, 14th Sept.
	'Fort Sztuki '97', *Gazeta Wyborcza*, Krakow,24th Sept.

'You Have To Be Careful How You Live Your Life', *UKS* #3/4, Oslo
'Amorph!', *Live Art Magazine* #17
'Transart Communication', *Castrum Novum*, Slovakia, 7th Oct.
'Transart Communication', *Jump Magazine*,Budapest, Oct.
'Festival Crosses Artistic Borders', *Budapest Week*
Recontre Internationale d'art Performance, Le Lieu, Quebec [cat.]
Crakovian Meetings, Bunkier Sztuki, Krakow [cat.]
Rootles '97, Hull Time Based Arts, UK [cat]
Words & Pictures #10, final edition, London [box multiple]
Performance Index, by Heinrich Lüber, Basel, Switzerland
Ceasefire, CD, Akshun Services, UK

1998 *Winter Light*, Kunstfabrik, Köln, Akshun Services [cat.]
HomeWork, Scores, statements, notes for akshuns 1976-1996, Akshun Services [cat.]
'Bull', *Live Art Magazine* #19, Feb/March
'Subversions', *Live Art Magazine* #20, April/May
'Intermedia', *Irish Times*, 2nd May
'Fort Sztuki', *Zywa Galeria Magazine* #2, Krakow, March
'No Slime This Time', *Asahi Evening News*, Tokyo, 30th July
'Asian Performance Art Series', *Artworld* #10, Korea, Oct.
Out of Time, Hull Time Based Arts 1984-1998, HTBA, UK
Performance in NRW, Kultersekretariat Nord-Westfalen, Germany [cat.]
Occupational Hazard, Critical Writing On Recent British Art, ed. D. McCorquodale et al., Black Dog Publishing, London
Performance: Live Art Since The 60's, by RoseLee Goldberg, Thames & Hudson
The Divine David Presents... World Of Wonder production for Channel 4 TV, UK

1999 'Cardiff Art In Time', *Y Side Gelf*, BBC TV Wales
6th Nippon Performance Art Festival, Japan [cat.]
The Psychology of Performance Art, by Anthony Howell, Harwood Academic Publishers
Learning To Fly, *Nippon Camera*, Japan, June

'Infusion '99', *Circa* #89, Autumn
0044, ed. Peter Murray, Gandon Edition, Ireland
For Eyes & Ears, Odense Performance Festival 1999 [cat.]
Dyrisk Brutalitet, Lordags Fri, Fyens Stifistidende, Denmark, 11 Sept.
Art Club [Helsinki report], CNN TV Worldwide

2000 *For Eyes & Ears, Odense Performance Festival*, Le Bloc, MAPRA, Lyon, France
'No National Identity, Please. We're Irish', *Irish Times*, 9th Feb.
'Full Nelson 3', *Seattle Weekly*, 2nd March
'Promises Of Paradise', *Circa* #91, Spring
'A Pub Crawl', *City Limits*, Newsletter, Belfast, 6th May
Clean Slate, Wales Art International & Artists Project, Cardiff [cat.]
Homework, score notes, statements from akshuns 1976 – 2000, Krash-Verlag, Cologne

PUBLICATIONS

1979 – 1981 *A.K.A. F/ART*, international networking magazine, editions, contributing editor.
1981 *The Deed/Warzone Exiles*, edition of 2 poster designs, Orchard Gallery, Londonderry
1982 *The Hebephrenic*, performance document, Laughing Postman Editions, Portland
1984 *Snuff, Drawings Celebrating Georges Bataille*, Exiles Studio Edition, London
1985 *Panaphobia*, October Gallery, London
1993 *Tiltott 1980 – 1990*, double audio cassette document, ND, Texas
1994 *Working On The Bypass*, CD & book, ND, Texas, USA & Locus+, Newcastle upon Tyne
1995 *Crow*, Galerie QQ, Krakow, Poland
1995 – 1997 *Words & Pictures*, editions of box multiples, London
1997 *Ceasefire*, CD, Akshun Services, London
1997 *HomeWork*, scores & statements from performances
1976 – 1996 *Akshun Services*, London
1995 – Contributing editor, *ND Magazine*, Texas
1998 – Reviewer for *Live Art Magazine*, UK

FILM AND VIDEO

1978	*Start It/End*, video
1979	*Something In The Air* – 8mm
	Taylor The Gannet Goes Ape – 8mm
1981	*The Other Room* – 8mm
1982	*Terra Inc.* – 8mm
1983	*Dogz* – video
	Concrete(os) – 8mm
	Kincora – 8mm
1985	*Hot Dog... You Bet!* – video
1984	*Love Crimes* – 8mm
	Fragment 4 – video
1986	*Letter to Tokyo* – video
	Fugue State – 8mm
	Blue Star – 8mm
1987	*Freeway* – 8mm
1988	*The Dry Dive* – 8mm
1986-93	*The Avant Garde Film* – 8mm
1993	*Dead Cert* – 8mm
1995	*Gridlock* – video
1997	*Eat My Words* – video

Compilations

1998	*Akshuns 1981 – 1997*
1998	*Love Akshun*
1999	*Small Time Life Akshuns*

LIVE MUSIC

ASK MOTHER

1977	Queens University, Belfast
	Ulster College of Art, Belfast
1978	Hayloft, Lisburn
	Arts Council Gallery, Belfast
	Assembly Rooms, Lisburn
	Harp Bar, Belfast [5 weekly residencies]
1979	Harp Bar, Belfast
	The Mansion, Dunmurry
	Castlereagh Youth Club, Belfast
	Pound Club, Belfast

FRAGMENT

1984	Fridge, London
	Clinker, London

SELF RIGHTEOUS BROTHERS

1995	Soho Jazz Festival, London
	Tate Gallery, Liverpool
	Underwood Gallery, London
	Plunge Club, London
1996	Soho Jazz Festival
	Plunge Club, London

W/DANIEL BIRY

1994	Bedsit To Loft, London
1995	UK Electronica, London

SOLO

1983	Clinker, London
	Moonlight Club, London
	Pyramid Club, New York
1994	Marquee, London
	Custard Aquarium, London

RECORDED SOUND [SELECTED]

1978	*Beat*, Ask Mother [Downtown Radio]
1979	*Prevention Act*, [EP], Ask Mother [Good Vibrations]
1980	*Janus Head*, [single], Italy
1984	*The Tourist*, Perfo-4, [LP], Holland
1986	*ND*, [comp], Austin Texas
1993	*Tiltott 1980-1990*, [double cassette box limited edition comp.], ND, Austin, Texas
1994	*Working On The Bypass*, [CD], ND, Austin, Texas, [Locus+ limited edition 1000]
1997	*Ceasefire*, [CD], Akshun Services, London, [limited edition 500]
1999	*Captain Murnau*, [comp-CD], Italy
2000	*Live Akshun 1996 – 1998*, [CD], Trace Limited Edition, Cardiff
2001	*East Poppy Fields*, [CD], (with Daniel Biry and Alex Borak)

CURATORIAL ACTIVITIES

1980	*First Degree Murder*, Ulster University Gallery, Belfast
1981 – 1983	*Zen Abattoir*, multi-media events, London
1982 – 1983	*Visa Video Events*, London & Brighton
1985	*WTSHTF Events*, London
1985	*Panaphobia*, October Gallery, London

1989	*Hardcore Live Art Tour*, USA
1991 – 1994	*Exploding Cinema*
1993	*Dead Cert*, Performance Tour, Texas
2000 –	*Trace*, Installation Art Space, Cardiff
2001	*Span [2]*, Performance Event, London

AWARDS

1980	Greater London Arts Projects Grant
1982	BBC TV Riverside Photocopy Award
1983	Arts Council of Northern Ireland
1986	Arts Council of Northern Ireland
1988	Irish Exhibition of Living Art
1989	Arts Council of Northern Ireland
1995	British Council travel award [Poland]
1995	Arts Council of Northern Ireland
1996	Arts Council of England travel & research grant
	Franklin Furnace Fund for Performance Art, New York
1997	British Council travel award [Finland]
	British Council travel award [Slovakia]
	British Council travel award [Germany]
	Arts Council of England travel & research grant
	Arts Council of Northern Ireland
	UNESCO
1998	British Council [Japan]
1999	Arts & Humanities Research Board Fellowship [UK]
2000	Wales Art International
2001	Wales Art International
	British Council (Canada)

RESIDENCIES

1996	Baltic Arts Centre, Ustka, Poland

NOMINATIONS

1994	The Arts Foundation, UK, Multi-Disciplinary Artists Award
1997	Pace-Roberts Foundation, USA, Residential Award
1999	Paul Hamlyn Foundation, UK, Visual Artists Award

TEACHING PRACTICE

1981 – 1983	Leeds Polytechnic, Fine Art Dept.
	Middlesex Polytechnic, Intermedia Dept.
	Portsmouth College of Art, Foundation Dept.
1991 –	Strathclyde University, School of Architecture & Building Science
1996	Dartington College of Art
1996	Ulster University, Belfast
1997	UNESCO Art Hansa, Köln, Germany
1997 – 1999	UWIC, Cardiff College of Art, Time Based Dept.
1998	Central St. Martins, Critical Fine Art Practice
	Fosbergs International School of Design, Stockholm, Sweden
	NIPAF Summer School, Nagano, Japan
1999	Camberwell College of Art
	Royal College of Art, Dept. of Illustration & Communication
1999 –	Senior Lecturer/Subject Leader, Time Based Practice, University of Wales Institute, Cardiff

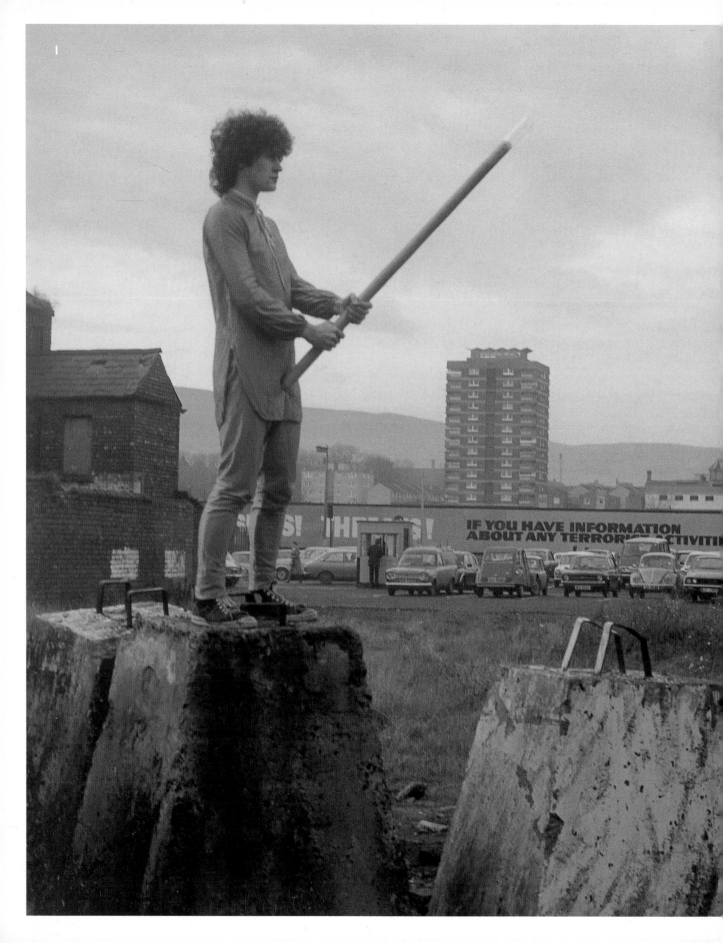

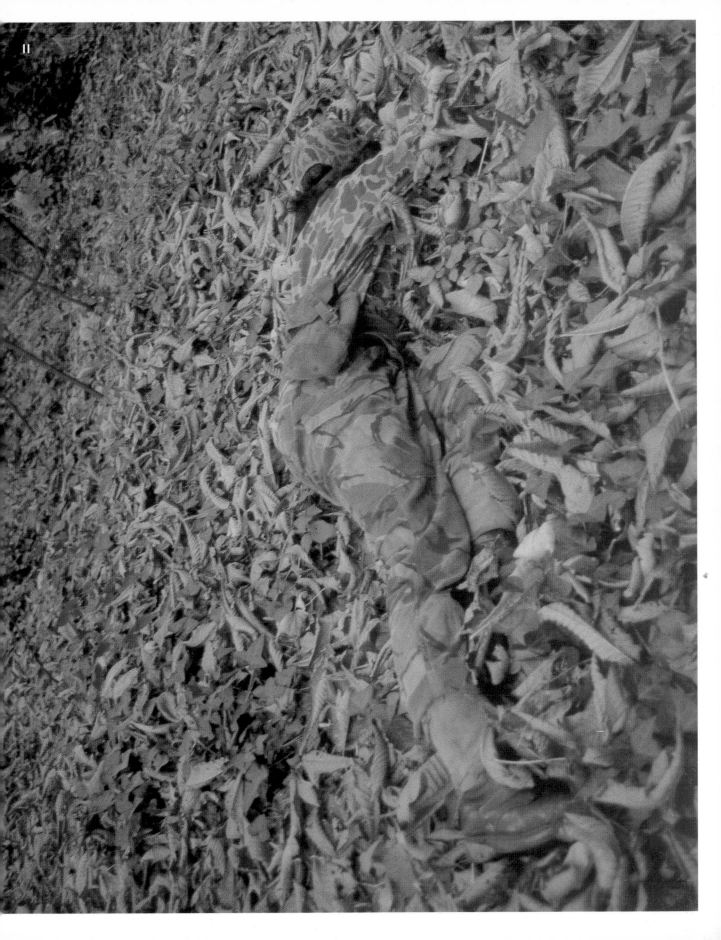

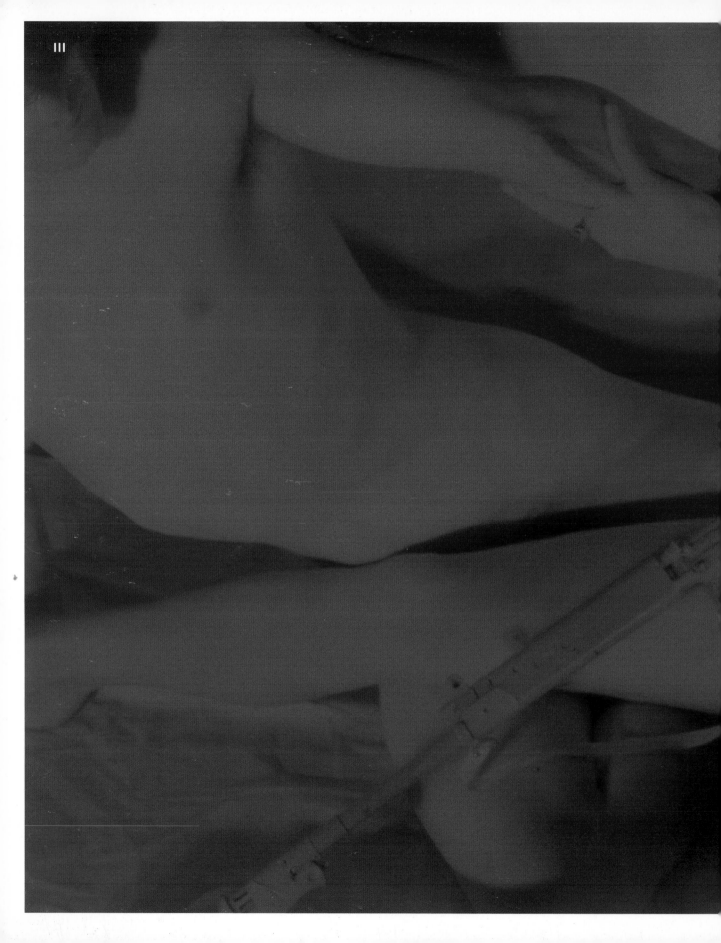

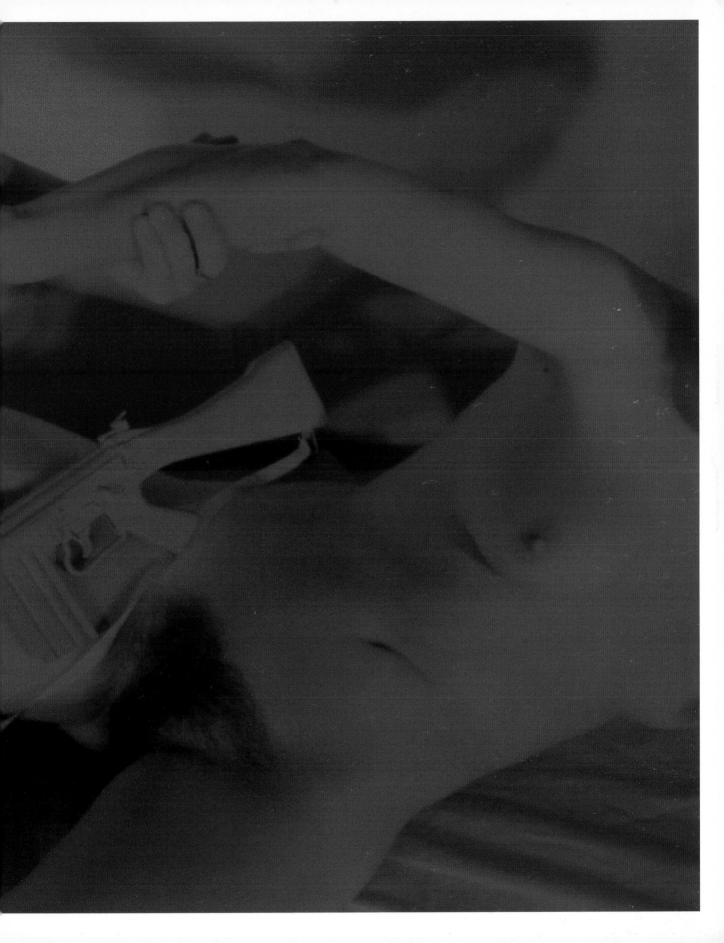

THE SCHIZOPHRENIC ---- FOOD FER THOUGHT

BUTTER COOKIES

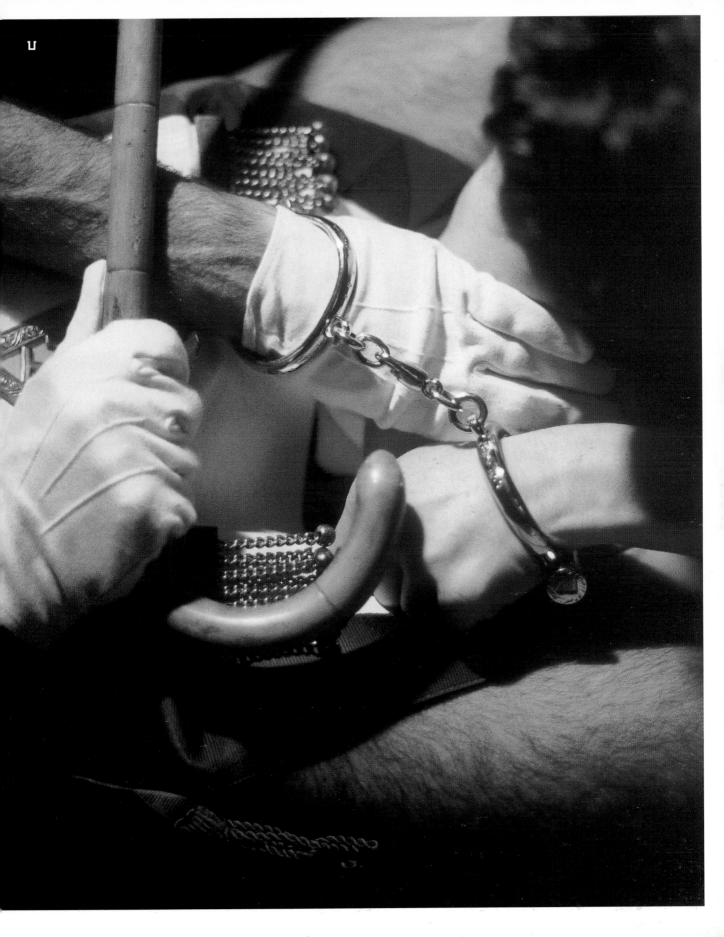

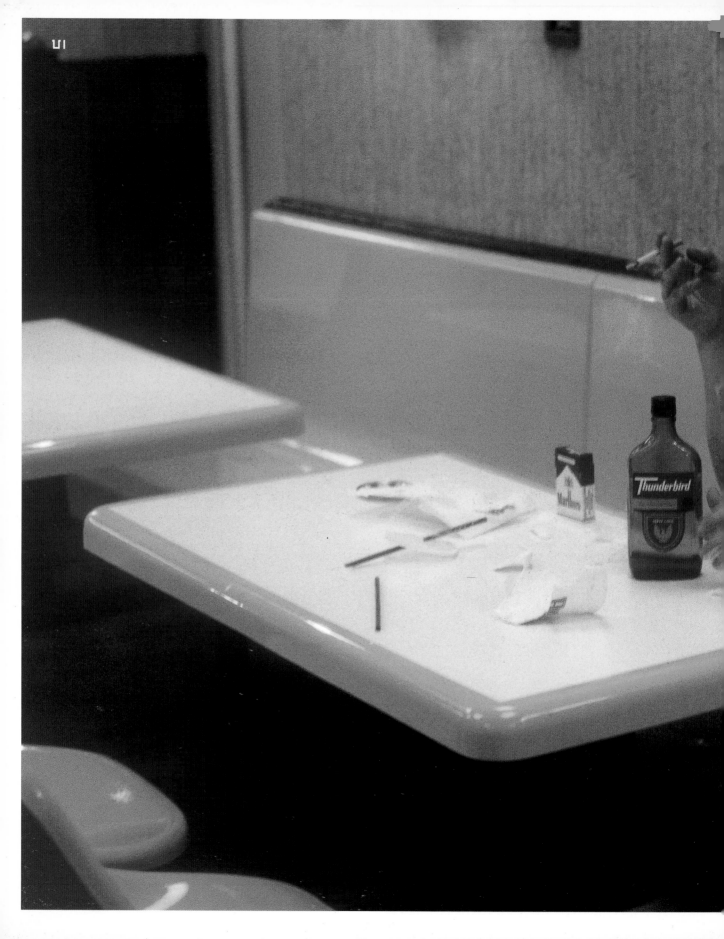

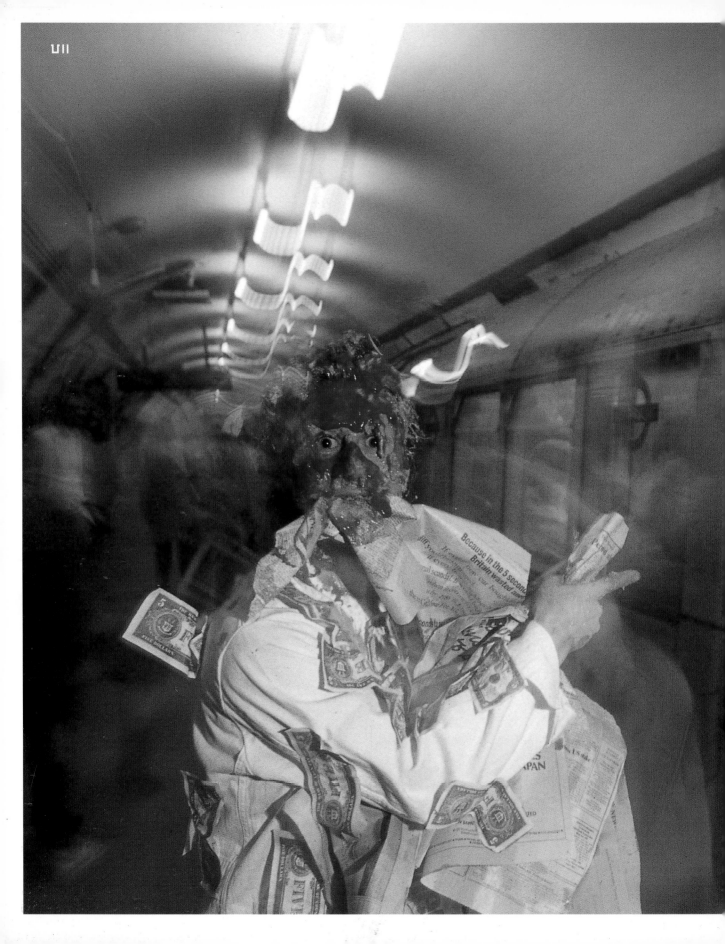

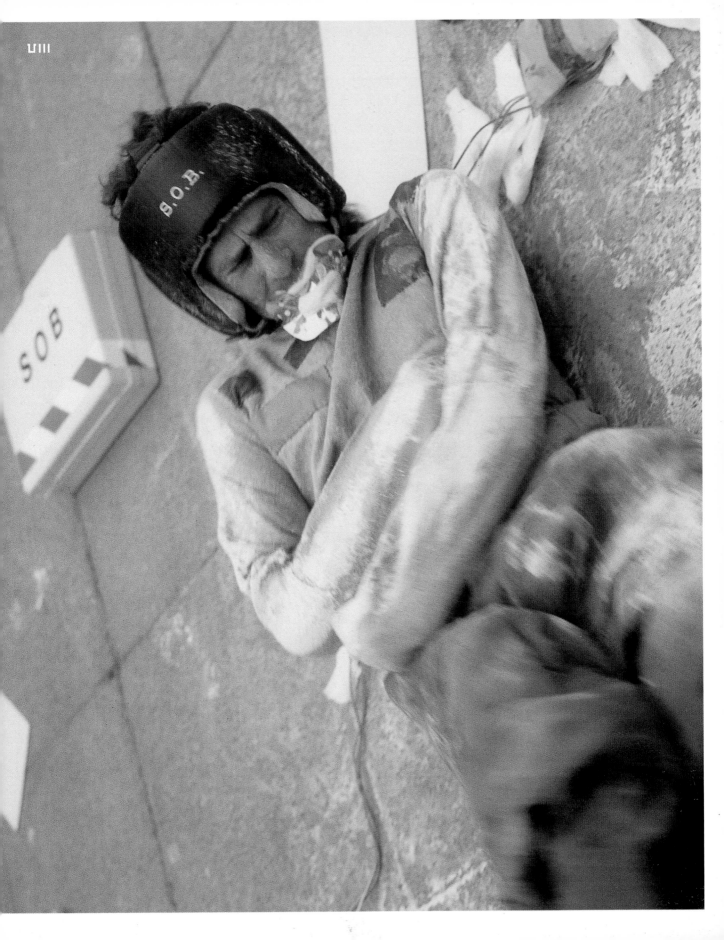

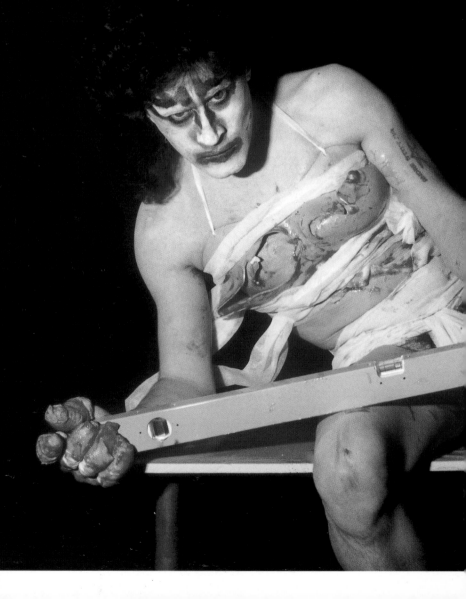

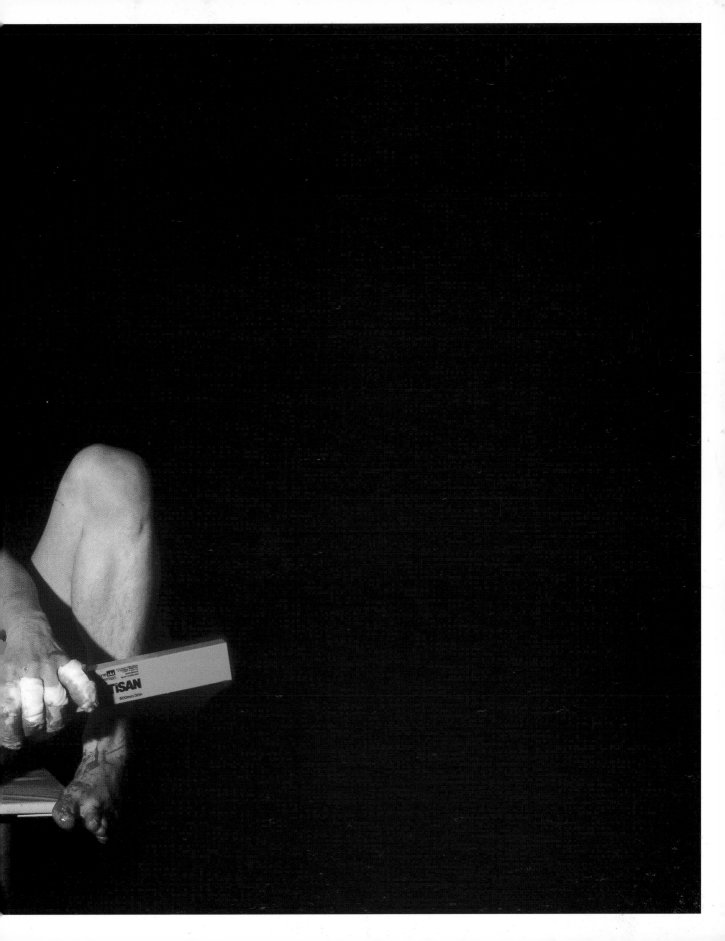

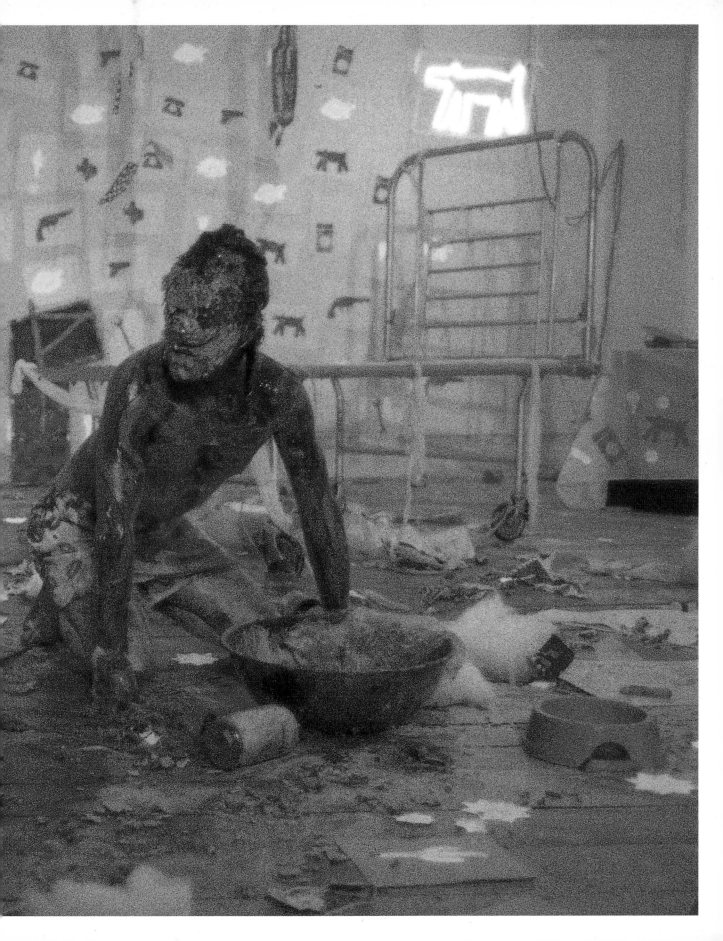

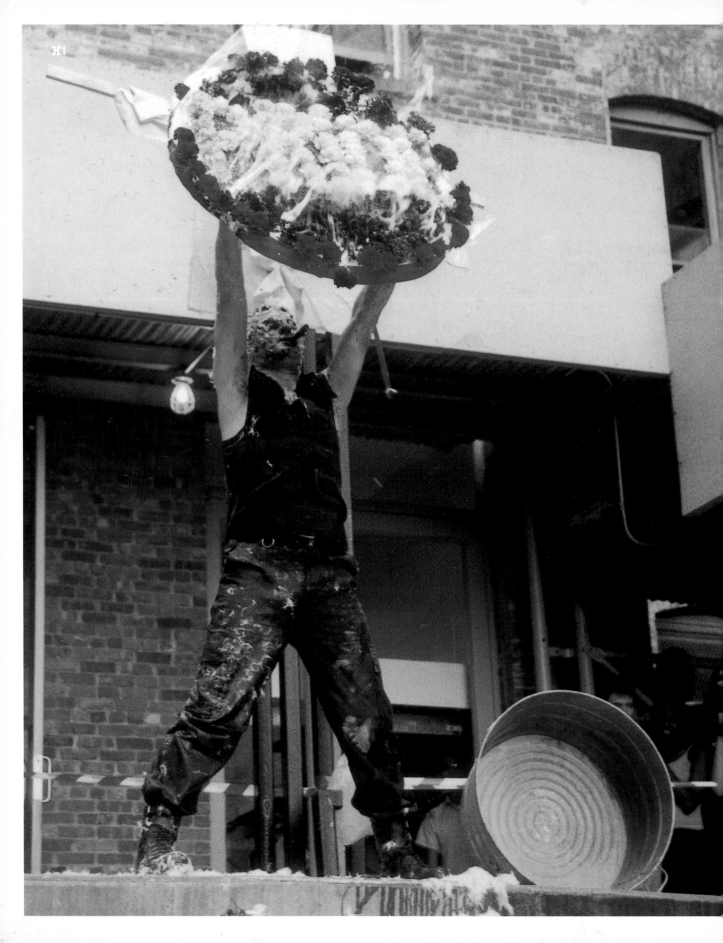

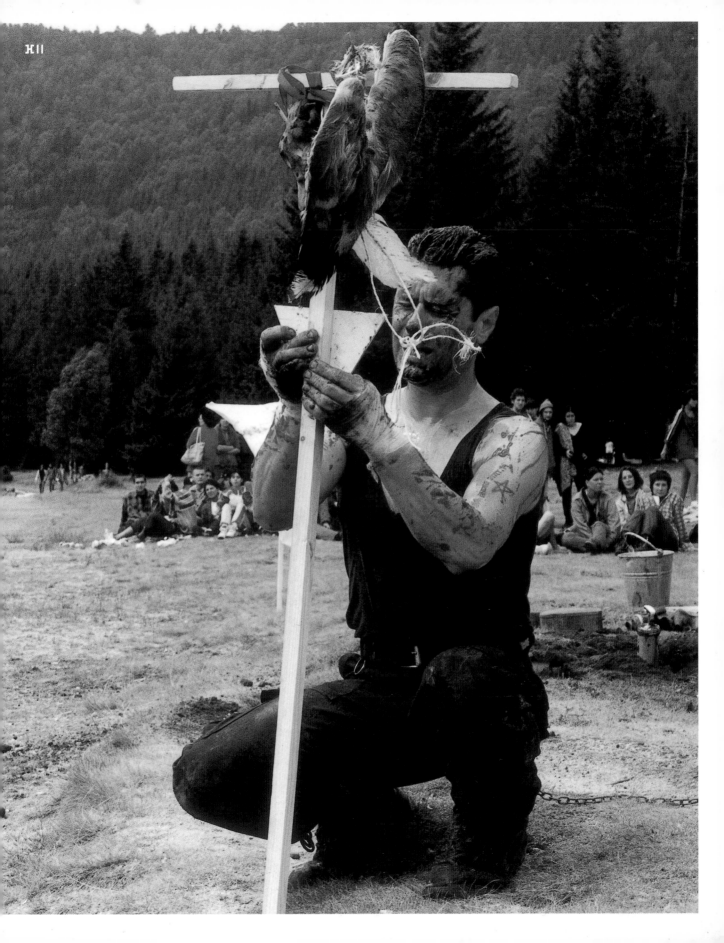

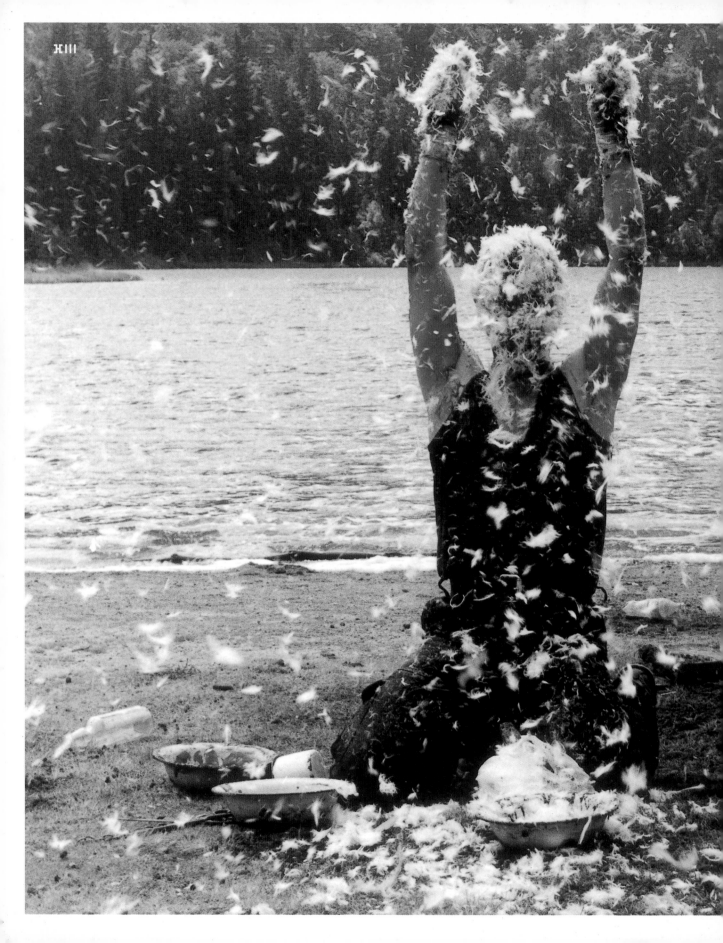

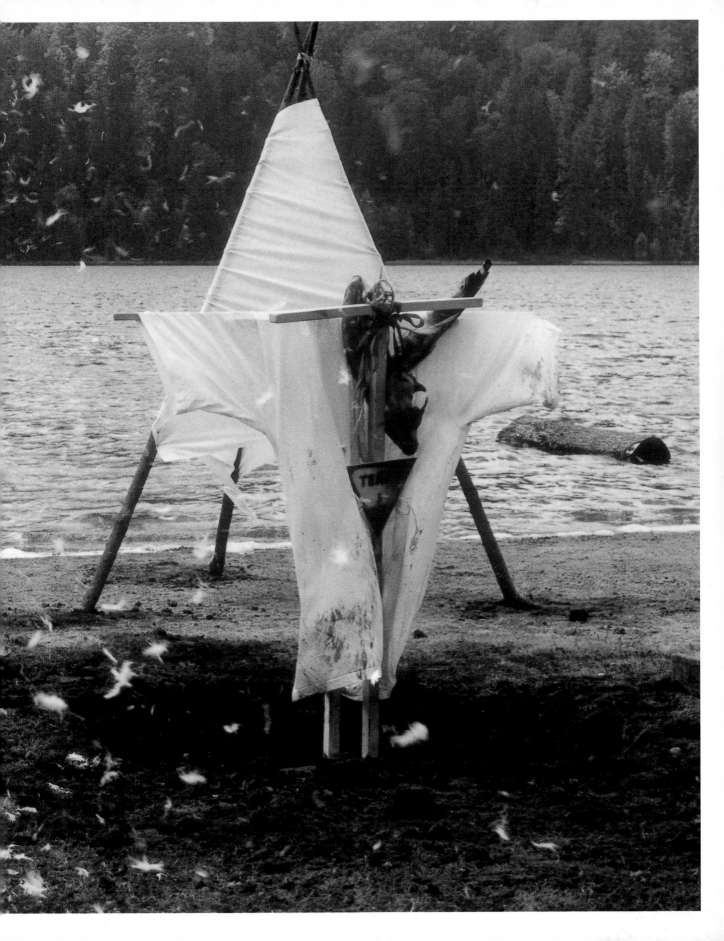

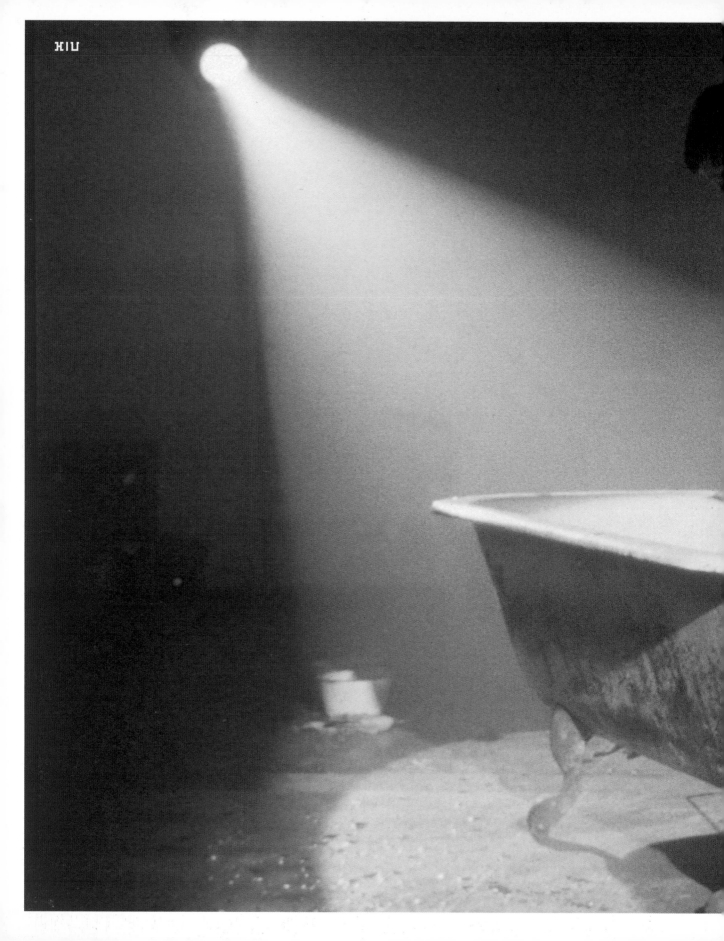

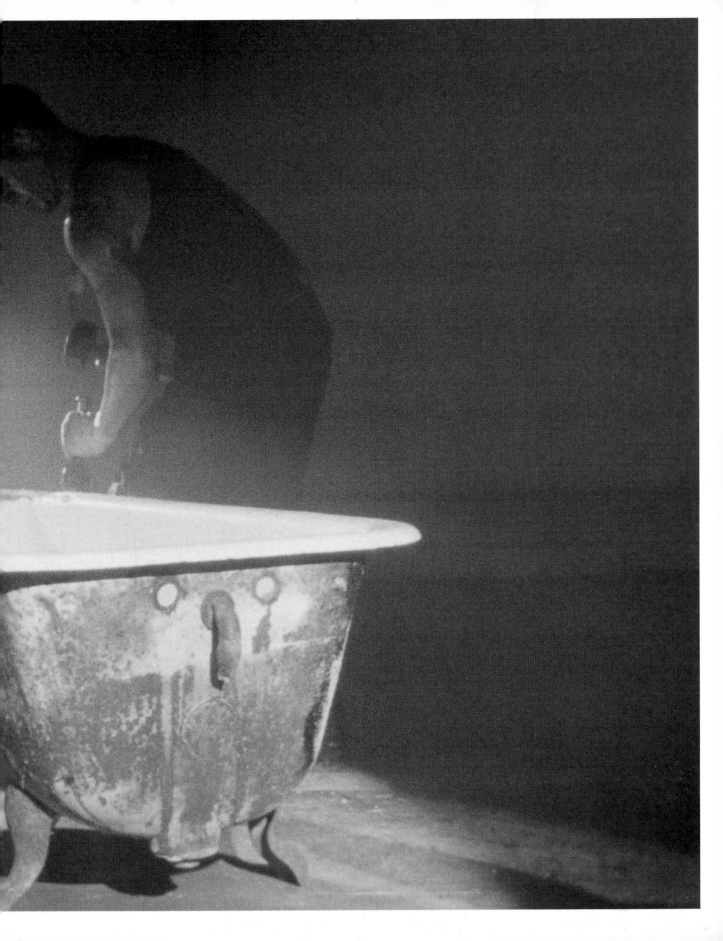

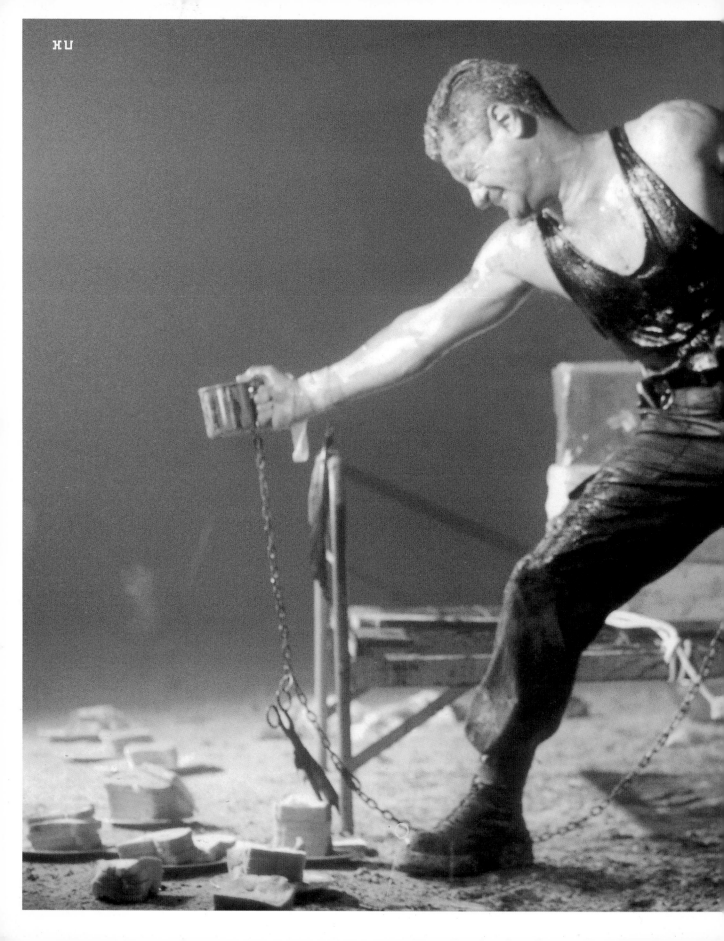

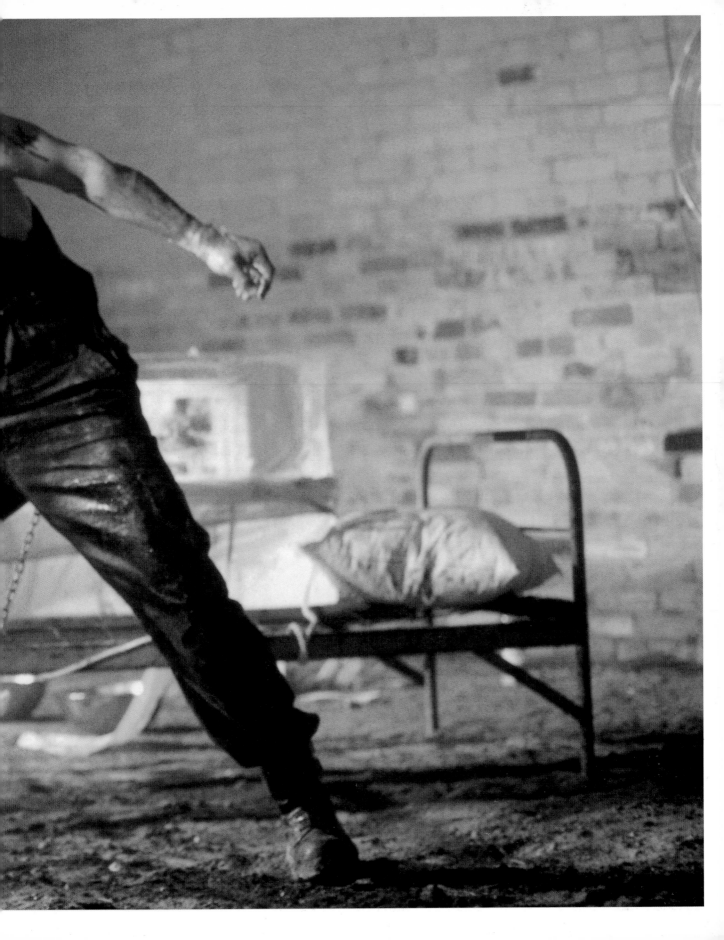

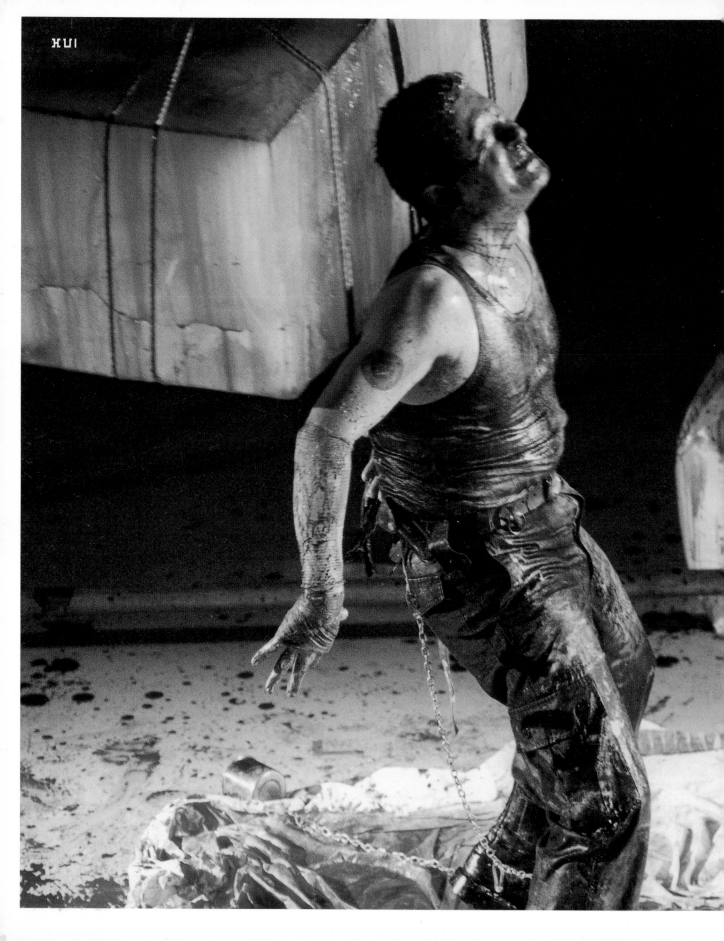

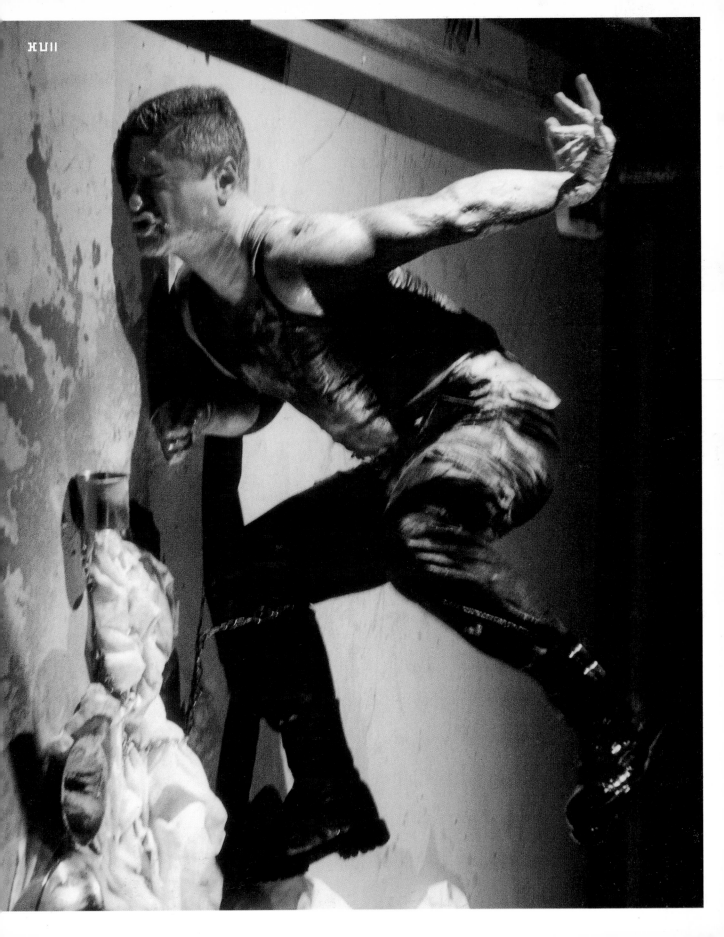

XLII

XLIII

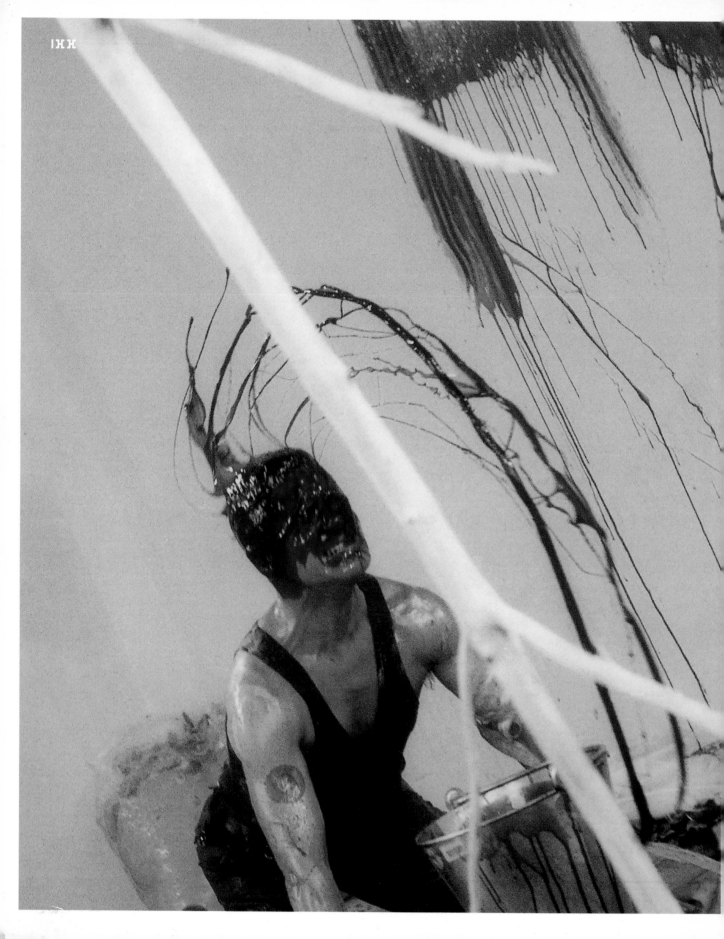

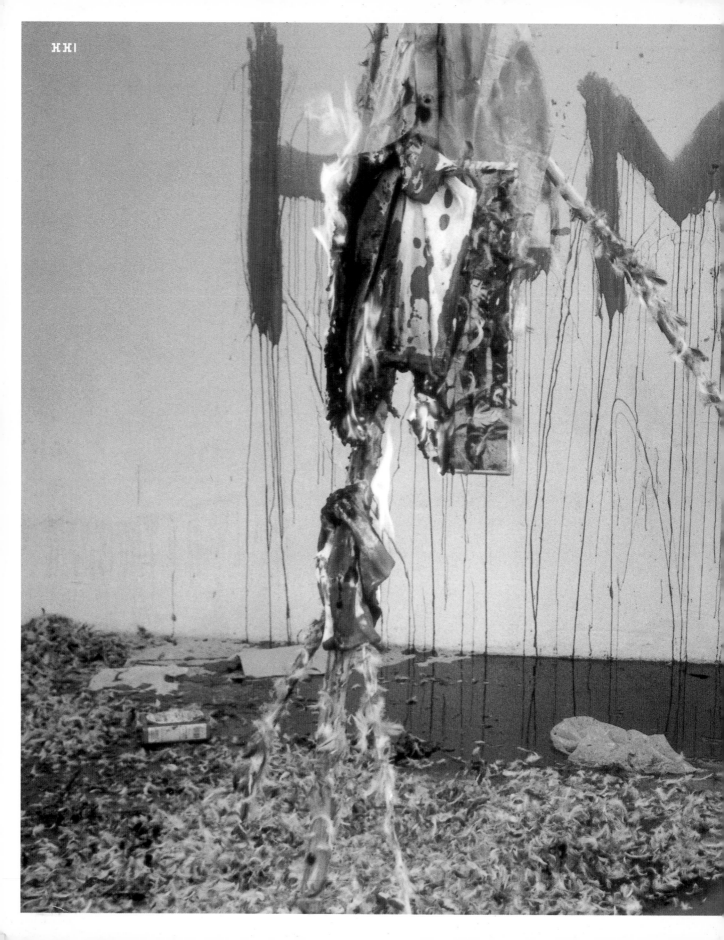

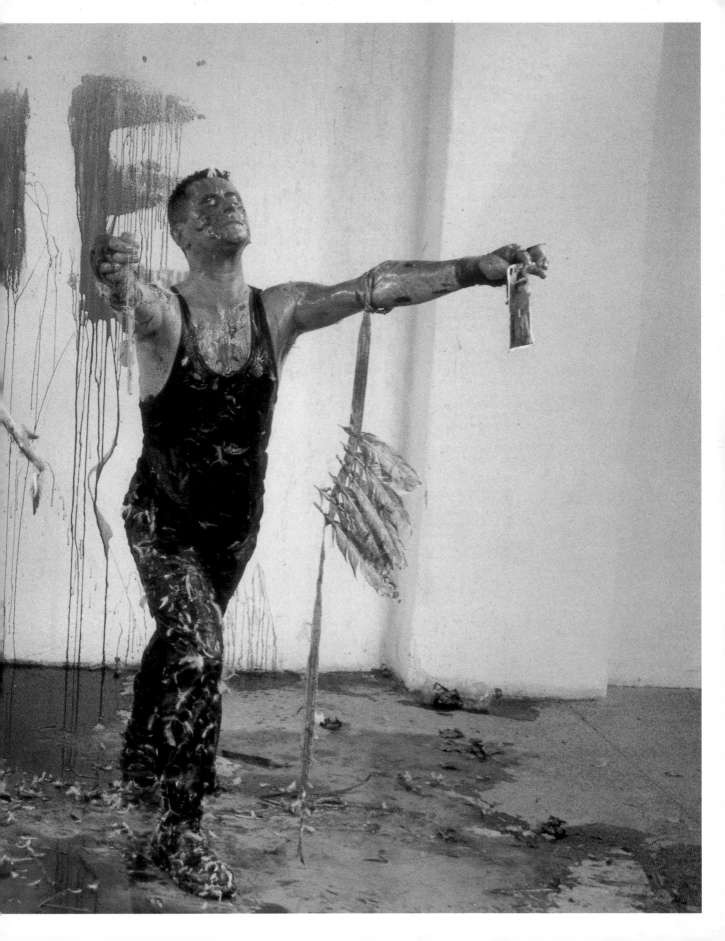

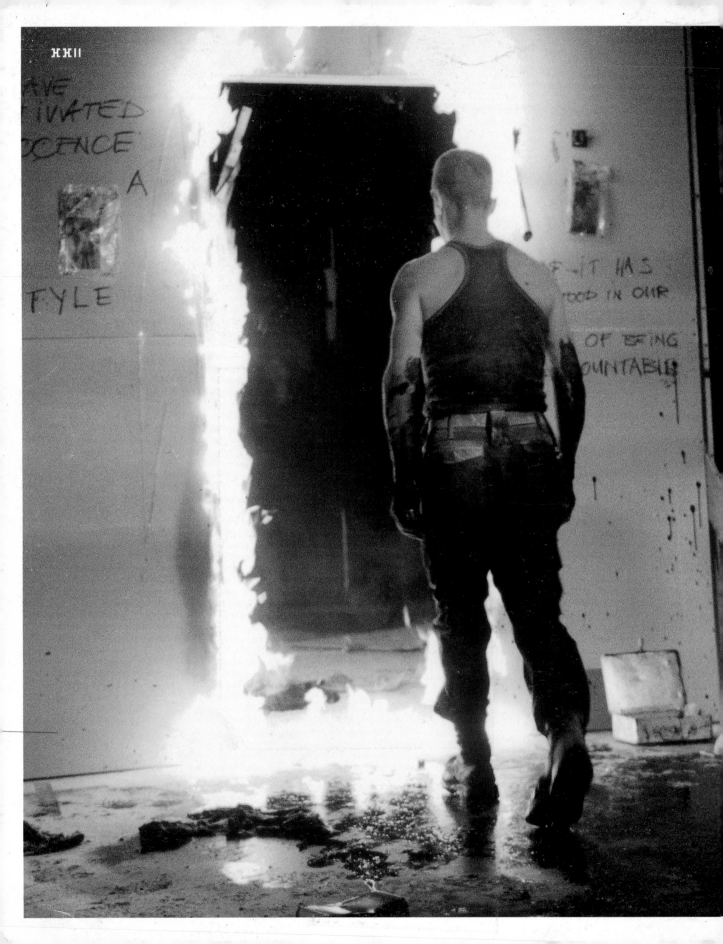